*Art and Life:*
*Aspects of Michelangelo*

PSYCHOANALYTIC CROSSCURRENTS
General Editor: Leo Goldberger

THE DEATH OF DESIRE: A STUDY IN PSYCHOPATHOLOGY
by M. Guy Thompson

THE TALKING CURE: LITERARY REPRESENTATIONS
OF PSYCHOANALYSIS
by Jeffrey Berman

NARCISSISM AND THE TEXT: STUDIES IN LITERATURE
AND THE PSYCHOLOGY OF SELF
Lynne Layton and Barbara Ann Schapiro, Editors

THE LANGUAGE OF PSYCHOSIS
by Bent Rosenbaum and Harly Sonne

SEXUALITY AND MIND: THE ROLE OF THE FATHER
AND THE MOTHER IN THE PSYCHE
by Janine Chasseguet-Smirgel

ART AND LIFE: ASPECTS OF MICHELANGELO
by Nathan Leites

# ART and LIFE ASPECTS of MICHELANGELO

NATHAN LEITES

NEW YORK UNIVERSITY PRESS
*New York and London*

**Library of Congress Cataloging-in-Publication Data**

Leites, Nathan Constantin, 1912–
Art and life.

(Psychoanalytic crosscurrents)
Bibliography: p.
Includes index.
1. Michelangelo Buonarroti, 1475–1564—Psychology.
2. Michelangelo Buonarroti, 1475–1564.  3. Artists—
Italy—Biography.  I. Title.  II. Series.
N6923.B9L38  1986    700'.92'4    86-8404
ISBN 0-8147-5021-4 (alk. paper)

CLOTHBOUND EDITIONS OF NEW YORK UNIVERSITY PRESS BOOKS ARE SMYTH-SEWN
AND PRINTED ON PERMANENT AND DURABLE ACID-FREE PAPER.

For Frederick Hartt

# CONTENTS

# LIST OF ILLUSTRATIONS

# PREFACE

HEN, in the pages below, I surmise a relationship between a certain state of Michelangelo's soul and a certain aspect of his art, I do not mean to assert that no other characteristics of the artist have contributed to that peculiarity of his creations. Often I myself indicate other connections; and of course I do not pretend to have exhausted my subject.

Asterisks at the beginning and end of a passage indicate that the conjecture in question is based on evidence which psychoanalysts have obtained from patients.

Describing Michelangelo's art, I quote, whenever possible, recent authors rather than presenting my own perceptions. Thus the characteristics of Michelangelo's works to be related to his life are mostly ascertained by observers unconcerned with these relations.

"To what extent do themes in Michelangelo's poetry express personal travail and to what extent do they repeat commonplaces? Without a systematic exploration, which we have not by any means made, of Italian poetry of the fifteenth and sixteenth centuries . . . it is not easy to determine the extent to which a work . . . uses customary motifs . . . without . . . expressing deeply felt experiences" (Garin 1966, 524–525). In the present study I shall proceed on the conjecture that in Michelangelo's poems "even words which had already been spoken by others are not imitations" (Friedrich 1964, 382). Thus "at first the theme of the loss of self appears as one of literary tradition. . . . [However]

with Michelangelo . . . this theme, as so many others anticipated by literature, enters into . . . [his] acute experience . . ." (op. cit., 357).

As I shall be concerned only with what Michelangelo's poems may disclose about that experience, I shall present passages as if they were of prose.

Often, for clarity and vividness, I shall let the Michelangelo whom I conjecture speak in the first person; and as if what was obscure in him had been fully conscious.

Emphases, unless otherwise indicated, are mine.

I wrote a draft close to the present text in 1981 and communicated it to several students of Michelangelo. Beyond the points for which I refer below to Robert S. Liebert's book of 1983 readers will notice others on which our views converge.

# CHAPTER 1

# AN UNMOTHERLY MOTHER?

WHEN MICHELANGELO before his old age presents the Virgin with her son, she is not apt to look at him. (This statement, as well as subsequent ones of its kind in the present chapter, calls for a comparison between Michelangelo and other artists—a task which I have not performed—which renders the points made below especially uncertain.)

The Virgin does not look at her son, we are told about this, as well as other traits in Michelangelo's portrayal of the Madonna with Christ, for a theological reason. In The Pitti Tondo, for instance, "Mary's eyes gaze into the distance" as "the Cherubim on . . . [her] forehead . . . [signify] 'gift of higher knowledge' " (Tolnay 1947, 102) (fig. 1): what engages her is not the present moment, but the Incarnation's entire course, and particularly the

1

Passion. But that stance of the Virgin was only one of several which were admissible, while none of them was required. What made Michelangelo choose it? *Probably *also* a fit between it and "a . . . personal level" (Hartt 1968, 43): a relationship—not necessarily one of sameness—between the stance he conferred upon the Mother of God and the one he remembered—consciously or obscurely, correctly or incorrectly—of his own mother or nurse.*

It is with this consideration in mind that we might note about The Pietà in Rome that "[she] does not . . . gaze upon the corpse as in all earlier Pietàs" (Tolnay 1947, 92) (fig. 2); just as "[the] men, women and children" who represent Christ's ancestors on the Sistine Ceiling "neither speak nor look at each other" (Tolnay 1955, 77)—and as Michelangelo became a recluse and came to present himself as one (chapter 3).

Sometimes we can observe Michelangelo correcting himself so as to reduce the mother's attention to her child: in a sketch for The Medici Madonna she looks down toward her son (Hartt no. 59), while, finally, in the Chapel, she looks over him.

She may not only not look at the child, but look away from him (see instances below). Yet Michelangelo in his poetry insists that love proceeds between eyes: the beloved informs me that she does not love me when she "denies her eyes to me" (Girardi no. 245, ll. 1–2).

For the most part not looking at each other, mother and child also do not share an object at which they are both looking.

Mary, before Michelangelo's old age, is not apt to be loving toward her son nor joyous about and with him. Abiud embracing all of her child (Hartt 1964, 131) and the drawing Hartt no. 178 (1517–1518?) are exceptional.

Nor is the Virgin with the child already expressing grief about what is to come three decades later. Supposing she is preoccupied with the Passion, she is so without showing distress; similarly—again, before Michelangelo's old age—toward her son taken down from the Cross. In The Pietà in Rome (fig. 2) "[she] does not weep . . . she only bows her head with half-closed eyes and, with a suppressed movement of the left hand, . . . yields to the inevitable. All maternal pain is overcome . . ." (Tolnay 1947, 91–92)—or did not have to be overcome. She shows "no stronger feeling

2

than resignation" (Weinberger 1967, 73), "not grief but grateful reverence" (Hartt 1968, 82). She may even seem "without expression" (Hibbard 1978, 28).

Thus the mothers in Bruges (with child) (fig. 3) and in Rome (with corpse) can "bear a . . . resemblance, although the circumstances . . . are . . . life and death" (Mancusi-Ungaro 1971, 44).

The mother is somber—and absent toward her son, "detached" from him, like the mother of Jesse who "pays no attention to him. . . . She is concerned with her own thoughts" (Tolnay 1955, 83). The Virgin of the Stairs (fig. 4) "seems oblivious to the world about her (Tolnay 1947, 75), she is a "solitary mother" (op. cit., 76); in Hartt no. 57 the Virgin is "almost oblivious of the child in her arms . . ." (In The Victory (fig. 5) the victorious youth "seems to have forgotten" his defeated middle-aged enemy: "he turns his shoulder away with a sullen look; his face . . . expresses sadness . . ." (Tolnay 1975, 94), but hardly about the fate of the vanquished.)

Absent and somber, the mother may engage in gestures which in another mood would be loving. While The Virgin of the Stairs (fig. 4) covers her child with her cloak, she is doing so "absent-mindedly" (Sterba and Sterba 1978, 166); while The Pitti Madonna "wraps him [the child] in her cloak as if to protect him," "her head is raised and she has a distant look . . ." (Tolnay 1975, 17). She may draw the child closer to her without looking at him (Tolnay no. 390).

When in The Taddei Tondo (fig. 6) the little St. John frightens the Child by advancing a goldfinch toward him, the mother does allow her son to seek refuge in her lap; at the same time she "turns lovingly to St. John, but pays little attention to her child" (Sterba and Sterba 1978, 166). Indeed, not only is the expression of her face turned toward the other child more tender than we would by now expect, but also less somber.

When the Child is engaged with St. John, the mother finds it easier to look at both of them, or even at him only (Tolnay no. 87 and 246 v).

Even physically the mother is apt to fall short of fully supporting her son.

Sometimes this may be readily apparent, as when the son's head or limbs fall into the void (The Pietà in Rome, Tolnay nos.

3

270 r, 431 r, 433 r). At other times it may require close inspection to reveal The Virgin of the Stairs who nurses, avoiding to touch the child with her hands (fig. 4); or The Doni Madonna's "fingers in both hands . . . clenched . . . unsupportive of the infant" (Liebert 1983, 87) who has to hold on to her hair (fig. 7). The Medici Madonna (fig. 8) "offers little support to Jesus. Her right arm hangs limply at her side . . ." (op. cit., 91). The mother may hold the child at arm's length and at his risk, "supporting the child in an improbable movement" (Tolnay no. 246).

Or the lack of maternal support may be flagrant (and then more easily justifiable by faith), as in The Pietà for Vittoria Colonna (fig. 9) where the Virgin is turned toward Heaven: "At this lady's request, he made a . . . figure of Christ when he is taken from the cross and would fall as an abandoned corpse at the feet of his . . . mother, if he were not supported . . . by two little angels . . ." In contrast, "for love of this lady he also did a drawing of Jesus Christ on the cross . . . [where] we see that body not as an abandoned corpse falling . . ." (Condivi, 103). While "in other Pietàs the Virgin . . . supports the dead body and touches it with one or both hands," "in Michelangelo's image [there is] . . . the Virgin's desistence, raising her hands at this moment, disengaging them even as the body is being taken . . ." (Steinberg 1970, 268–269).

As the mother fails to be turned toward her son, he may attempt to engage her, as in The Medici Madonna (fig. 8).

She will then merely suffer her child's initiatives upon her body (Hartt no. 178). In Hartt no. 440 she is permitting him to play between her feet. Whereas in Tolnay no. 391 r "at first the Virgin was kissing Jesus, later . . . the artist made the Child kiss and embrace her." So far from at least observing what he is doing to her, she is looking away, as also in Tolnay 23 v and 248 r, as well as in Hartt no. 438, with regard to the infant sucking.

"To the . . . grasp of his left hand she [the Medici Madonna] lowers a yielding shoulder . . ." (Steinberg 1971, 145). Yet he only "appears" to be nursing (Steinberg 1968, 349), he merely "nestles against" his mother's breast (Einem 1973, 104): for it is covered. The child's mouth does not even seem to be aiming at the nipple (fig. 8).

4

On a sheet with a drawing of a woman nursing a child Michelangelo wrote *dagli bere,* give him to drink (Hartt no. 120).

"[When he] carved his signature on [The Pietà in Rome], the only . . . one that appears on any of his sculptures . . . the place he chose . . . was the strap which . . . presses . . . against the mother's bosom" (Hartt 1974, 417).

Michelangelo fears and scorns the "dry tree to pluck our fruit" (Gilbert no. 6, l. 14), the woman incapable of "giving to drink" the aged one with sagging and withered breasts averting her face from the child attempting to nurse in the lower left of The Children's Bacchanal (fig. 23) and to the left in the drawing of Michelangelo (?) Coiffed in a Boar's Head (Casa Buonarroti) as well as in The Crucifixion of St. Peter, a "hag with dangling, empty breasts" (Hartt 1964, 156).

Michelangelo's mother seems—in the practice of his milieu—to have nursed him only during his first few weeks. In his preserved words—except that he twice advised his nephew that any daughter of his should receive her first name (once calling her his mother, the other time merely writing her first name).

His wet-nurse was the daughter and wife of a stonemason. Words of Michelangelo's reported by Condivi seem to say to his mother: you are not my mother—in the way Michelangelo writes to a brother: "Now I am certain that you are not my brother, because if you were you would not threaten my father" (letter to Giovan Simone, June 1509. Ramsden no. 49). "Michelangelo," Condivi reports, "is want to say, perhaps facetiously or perhaps even in earnest . . . that the nurse's milk . . . often, by altering the temperature of the body which has one propensity . . . may introduce another, quite different from the natural one" (Condivi, 7). It was his wet-nurse, he appears to convey, who through her milk brought forth, by her own connections with male sculptors, Michelangelo the sculptor.

While Michelangelo rose in due time to the social hierarchy—as has often been noted, Cavalieri and Colonna, del Riccio and, say, Giannotti were of higher origin than he—he always maintained in his houses and workshops with his *garzoni* the lower-class life of his foster home at Settignano; as he did also during his prolonged sojourns near marble quarries; living with and for

the "hard and alpine" stone he loves, which is the principal matter of his nature devoid of vegetation (Liebert 1983, 221–222).

Yet he had to leave his nurse (at an unknown date), to see himself succeeded by three siblings and to have his mother die when he was six.

Half a century passed before a woman became important for him again and probably Vittoria Colonna was less attached to him than he to her.

In his poetry Michelangelo developed—beyond the Petrarcan theme of the Lady who makes men suffer by making them fall in love with her and then refusing them—a distinctive image of the woman devoid of love—"she does not love herself" (Gilbert no. 66, ll. 38–39), made of a "hard" stone he then ceases to love: "The stone where I portray her resembles her . . . because it is so hard and sharp" (Gilbert no. 240, ll. 7–9).

Not only does she thus bring about the death of the man attached to her, she is out to murder him. "This woman is bound, in her ungoverned rage, that I'm to burn . . . and perish, my blood lets, pound by pound, unnerves my body . . . heaping me with disdain . . ." (Gilbert no. 170, ll. 1–13). "I see your only pleasure is my ill. . . . There is no peace for you unless I grieve. . . . I pack and fill my heart with sorrow, at your . . . wish. . . . Your . . . cruelty is . . . fierce . . ." (Gilbert no. 244, ll. 1–11).

Woman remains forever the being who can kill me by withholding food and thereby "change [me] to what won't even weigh an ounce, and perish" (Gilbert no. 170, ll. 3–4).

The drawing Hartt 438, 1535–1540 (?) is "the last appearance . . . of . . . the Virgin nursing the child": "with . . . [a] haunted glance and a face averted from the child vigorously advancing toward her breast; but now her hands grasp his shoulder and thigh."

In the drawing 439, 1545 (?), again of Madonna and child, which follows in Hartt's sequence, a new life has begun with "the *passionate* directness of the *maternal embrace*" (fig. 10).

The next drawing in the same sequence, No. 440, 1553, returns to the tenacious past: the Virgin listens to a young man,

6

inattentively permitting the child to play between her feet—but he is staying there (fig. 11), not on the point of leaving as in The Bruges Madonna (fig. 3).

But in "perhaps the last drawing" of Michelangelo that is preserved, No. 441, 1560–1564 (?) there is once more a "blinding embrace" between mother and child (fig. 12).

And in a drawing of Mary and her son hanging on the cross, No. 429, 1550–1560 (?) the mother presses her arm and cheek into her son's thigh; she who had during seventy years of Michelangelo's imagination limited contact with his body.

For most of that period Michelangelo had avoided women.

He was drawn toward men.

Particularly around the time of his father's death in 1531 (Liebert 1983, 178).

At that time Michelangelo formed his only full attachment to a man who rejected that very fulness and made Michelangelo reject it too (chapter 8).

Michelangelo turned away from men and began to imagine the son loved by the mother.

7

# CHAPTER 2

# SEPARATING AND MERGING

SCULPTING, Michelangelo's central act in art, is for him separating an already existing figure from that with which it is to begin with merged, stone.

That belief of being subject to a state of affairs outside of him (chapter 7) wards off an opposite sense of imposing his idea upon formless matter: a sense he may in a rare instance express to counter a flagrantly passive disposition. "Sometimes," he points out in a madrigal to a "Lady," (presumably Vittoria Colonna) "good actions for the still trembling soul are hidden by its . . . body surplus (*superchio*)"; then "the husk . . . you alone can pull (*levare*) from off my . . . surface"—"just as (*si come*)," he adds incongruously, "we put (*ponere*) . . . into the . . . stone a . . . figure" (Gilbert no. 150, ll. 1–11). It is only when he demands of the "Lady" that she "sketch (*disegnare*) upon me . . . [from] without"

that he adds "as I do on a bright page or on a rock which, *having nothing in it*, takes what I like" (Gilbert no. 109, ll. 11–13).

Usually he subdues this belief by its opposite: all he does, he claims, is to transform an embryo into a self-contained being (with no intermediate infancy). "The best of artists," he affirms in often quoted lines of a sonnet, "never has a concept [which] a . . . marble block does not contain . . ." (Gilbert no. 149, ll. 1–2). "Rich and crude pictures are in the marble" (Girardi no. 84, l. 3), even "the high, low and middle style are in the pen and the ink" (ibid., ll. 1–2).

That with which the precious being brought forth by Michelangelo is initially merged is of one piece: the "marble block" envisaged in Gilbert no. 149 is *solo*. While "piecing was . . . considered a sign of . . . incompetence" (Schulz 1975, 370) by many of Michelangelo's contemporaries, he seems to have rejected it with a distinctive emphasis. "The . . . creed that only one block must be used in a statue was shared by Michelangelo throughout his life . . ." (Weinberger 1967, 85).

It requires *ingegno* to discern in the rocks the blocks which in turn contain the figures Michelangelo wants to reveal: a belief contributing to his protracted sojourns in the mountains of Carrara and Serravezza; thus in part answering the question, "could this . . . work not have been furnished by others . . .?" (Körte 1955, 299).

While Michelangelo was born from a mother he had not created, his sculptures were born from mothers whom he had brought into existence; selecting them as bearers of the sons hidden in them. So far from the son being secondary, at best, in the life of the mother—*as the young Michelangelo may have felt—he is the only reason for the marble mother's coming into being.*

*Separated from the mother—who may seem to find it easy, even agreeable to be rid of her son—unaided by her he may feel incapable of surviving (chapter 3).* In contrast, the sculpture he separates out of the block with which it was merged is self-sustaining; and Michelangelo's armed hand is justified in obliterating that block on behalf of the superior entity which it imprisons. "Cutting away *(levare)*," not "building up *(porre)*," is the essence of sculpture (letter to Benedetto Varchi, March 1547. Ramsden no.

280). The sculptor does to the block what God does to man: "you [God] strip and draw it [the soul] from the body" (Gilbert no. 291, l. 12), "Lord . . . who dresses and strips off each soul" (Gilbert no. 300, ll. 5–6). When Michelangelo's mother died and he was six years old, he *probably felt he had killed her, and probably conceived an obscure sense of guilt which stayed with him* (and *may in part have accounted for the intensity of his fear of death: he would be killed in talion).* This sense of guilt was *probably both revived and assuaged by his repeated intent and act of destroying the marble blocks he had selected for his sculptures; blocks which appeared to him consciously as mere *superchio*, surplus, with regard to the figures they contained.* He is then doing only what (as I have noted) God is doing to man and what he asks Vittoria Colonna to do to him "in mercy": to "trim any surplus down" and thus to "enhance the little that is of worth in me" (Girardi no. 234, l. 12). "Good actions for the . . . soul are hidden by its . . . body surplus, . . . the husk . . . raw . . . hard . . . coarse which you [Lady] alone can pull from off my . . . surface" (Gilbert no. 150, ll. 5–10).

Yet Michelangelo, with all his urge to release the contained, also desires to preserve its container. Before destroying containers, he will create enduring ones to shelter the products of that destruction. "He seems to have started work on all his great sculptural projects not with the statues, but with the enframing architecture . . ." (Hartt 1968, 19). In Hartt no. 149, a sketch for the façade of San Lorenzo, "Michelangelo [goes] . . . to . . . much trouble to work out the architectural framework without giving the faintest indication of the sculpture to go in it . . ."

He may not fully do away with a container. In The Virgin of the Stairs "he preserves at the edge a small strip of the original side of the block which . . . indicates the original surface" (Tolnay 1947, 77). In the Brutus "just above the right cheekbone the . . . surface of the block can . . . be discerned" (Hartt 1968, 276).

Even when nothing of the block's surface survives, the compactness of the composition which replaces the block may evoke it. "He can have had little interest in the . . . open profile—all

11

legs and arms—of Antonio del Pollaiuolo and Andrea del Verroc-
chio. . . . Michelangelo always maintained in his sculpture the
compactness of the original block" (Hartt 1968, 23). "All three fig-
ures [St. Anne, the Virgin and the Child in Tolnay no. 17 r] are
imagined as enclosed within the outline of a block of marble."
"The statue [David] is moving close to the original surfaces of the
block, on the side as well as in front. The elbow and the foot both
touch the invisible lateral surface" (Weinberger 1967, 86).

Thus the degree to which the block is destroyed as *superchio*
is reduced; its form survives; that form and the sculpture fill the
same space.

When Michelangelo creates an architectural or pictorial con-
tainer, he is apt to fill it. In The Laurentian Library "the doorcase
with a triangular pediment crowded into an outer framework with
a segmental pediment which is itself crowded within the space
between the two framing pilasters," is "typically Michelange-
lesque" (Murray 1980, 128).

When Michelangelo starts with substantial voids between
container and contained, he is apt to enlarge the latter to make it
press against the former, to make the container closely encompass
the contained, as the block surrounds its "figures grown largest
wherever rock has grown most small" (Gilbert no. 150, ll. 3–4).
"Between composition sketch and final work" it is "characteristic"
of Michelangelo to proceed to an "increase in the scale of the
figures at the expense of the surrounding space" (Hartt 1970, 267).
"In the later part of the Ceiling," it has often been noted, "the
scale of the figures . . . has increased until the field is barely
large enough to contain [them] . . ." (Murray 1980, 89). In fact,
"the impulse to invest the largest possible frame is observable in
most of Michelangelo's creative decisions. . . . A concept ex-
pands against . . . some . . . limit. . . . The artist . . . acknowl-
edges it in a paper margin, in the exterior facets of a marble block,
in . . . a niche, the . . . exigencies of a site . . ." (Steinberg 1975a,
7).

Closeness between container and contained entails discom-
fort for the latter, confining it (chapter 7). "Michelangelo's figures
. . . tend to *outgrow* their enclosures (think of the steady expan-
sion in size of Prophets and Sibyls of The Sistine Ceiling) . . ."

12

(Hartt 1974, 488). "[The bronze nudes] in the first half of the [Sistine] ceiling . . . are lying . . . in . . . outstretched poses. . . . In the other half of the ceiling the figures . . . have . . . attained herculean stature, are . . . subjugated inhabitants of the narrow field. . . . They no longer have room for an outstretched position, so their bodies are bent in strange sitting and crouching positions. Some are . . . putting their hands and feet against the sides as if to struggle against their . . . confinement" (Tolnay 1955, 70).

*But discomfort about being "bound up so tightly *(legato e stretto)*" (Gilbert no. 7, l. 3) also procures and serves to cover pleasure in being held so closely—as the child lovingly embraced by Michelangelo's late Madonnas and the adult Christ fused with his mother in the late Pietàs (see below).* "I live shut up here [Michelangelo's house in Rome] like the doughy middle inside the bread crust . . ." (Gilbert no. 265, ll. 1–2). Thus Michelangelo, feeling again and again "turned out of my house" (see below) creates for himself a close container.

To avoid discomfort, the contained may break through its container. "Uncomfortable within their spaces," the "latest" figures in The Sistine Ceiling "overflow them" (Hartt 1975b, 99). The Madonna della Scala and The Pitti Madonna violate their frames. "Seen from the sides the statues [The Capitani in the Medici Chapel] seem almost to spill from their niches . . ." (Hartt 1968, 179): Michelangelo "must have intended the liberation of The Capitani to contrast . . . with the imprisonment of the *capitelli* in the corners of the Chapel" (Hartt 1975b, 104). In fact, "throughout Michelangelo's work" there obtains a peculiar "relation between figure and frame": "the figures are in . . . conflict with their surroundings . . . project from . . . shallow niches, as the statues for the second story of the Tomb of Julius II were intended to do and as the two Dukes in the Medici Chapel do" (Hartt 1970, 351). "First," so ran a "custom" of Michelangelo's, "he made an elaborate structure, precise down to . . . minute detail, then, as often as not, violated it with the . . . figures placed inside" (op. cit., 133).* The wish to remain contained is both accompanied and warded off by the desire to break out.*

But Michelangelo also fears the consequences of something

inside him breaking out by its own will: "What is this thing [the beloved who] . . . through the eyes invades the heart and seems to swell in the small space inside? And what if it burst out?" (Gilbert no. 8, ll. 9–12).

Both strivings—to be contained and to break out—could be satisfied in the same structure. In the connection planned by Michelangelo between the Palazzo Farnese and the Villa Farnesina there is a "contrast between an enclosed space . . . and unlimited space" (Salvini 1978, 149).

Or one pole may prevail in a given structure. In a celebrated invention Michelangelo, in the vestibule of The Laurentian Library, *merges* columns with the wall (fig. 13), and in the Palazzo dei Conservatori there are "the half-columns and pilasters on the inner wall, where the relationship between projecting wall and recessed pillars recalls the membering of the walls of the vestibule in the Laurentian Library" (Einem 1973, 203). But in the Sforza Chapel of S. Maria Maggiore "the columns . . . *stand free in space like monuments*" (Lotz 1974, 259), the column is "independent of its surroundings" (op. cit., 248), becomes a "column monument" (op. cit., 262). "In S. Maria degli Angeli . . . antique columns were used by Michelangelo in a similar way. The motif recurs in the columns of the loggias of The Capitoline Palazzi. Free-standing columns appear in the preliminary studies for the Porta Pia . . ." (ibid.). For the window above the entrance to the Palazzo Farnese Michelangelo intended "pairs of free-standing columns" (Tolnay 1975, 161). Both the desire to be enclosed and the wish to stand free are thus fulfilled in contrasting objects.

The desire to separate and the wish to merge are combined in the *nonfinito*. To be sure, this propensity of Michelangelo's was also due to his "principle" of "constant revision" even during "execution": "it was an arduous method, even in . . . painting. . . . In . . . stone it must have been of surpassing difficulty . . . when a revised composition had to be accommodated in a partly-hewn block. One cannot imagine Michelangelo persisting . . . in the absence of a compelling personal interest to see the statue finished, or of the insistence of a . . . patron . . ." (Schulz 1975,

14

371 and 373). Yet there remains the *probable coexistence in Michelangelo of desires to merge and to separate, and the *nonfinito* as a compromise between them.*

A compromise accompanied, in the case of large projects for sculpture, by what one might call the *non-cominciato:* Michelangelo accumulating blocks, and then never touching them: due no doubt in part to external circumstances as well as his grandiosity in conceiving projects, but *probably also to what it obscurely meant to him to assault and destroy the block (Sterba and Sterba 1978, 172–173), to bring forth what it contained.* Such difficulties might even make Michelangelo stop at a point prior to acquiring blocks.

Still, of course, enterprises and even periods were not lacking in which Michelangelo's desire to complete won out over the aversion against so doing; and where the degree of completion might then be distinctively high; supporting his belief that he was capable of supreme achievement by himself rather than bound to perish when unaided (chapter 3).

"The plan he sponsored," it might be recalled about Piero Soderini in 1503, "was unexpectedly ambitious, that Michelangelo should carve twelve more than life-size figures of Apostles. . . . What made this exceptional commission possible was the speed at which the sculptor worked. The St. Peter's Pietà was finished in one year or a little more, the David was begun in 1501, with the stipulation that it should be finished in three years, and in two and a half it was practically complete" (Pope-Hennessy 1970, 12–13).

High and low degrees of completion are apt to coexist in the same work. Already in The Virgin of the Stairs "in those areas which are finished" there is "a degree of surface polish seldom, if ever, found in the work of Donatello" (Hartt 1968, 45). Generally, "in his unfinished statues . . . either the surfaces are complete save for the . . . polishing or they are concealed. . . . There is no intermediate stage as in the usual unfinished work of a sculptor, all surfaces brought to about the same condition . . ." (Hartt 1964, 23)—yet another coexistence of opposites in Michelangelo's work perhaps due in part to the presence of the contrary strivings discussed above.

15

While in Michelangelo's figures in Bologna "all details of the Saints are sharp," the treatment of the Angel is "soft": there is "blurring of all detail. . . . Not a line is clear, not an edge distinct" (Hartt 1968, 63) (fig. 14). In fact, "such a treatment is visible here and there in Michelangelo's early work, especially in background figures such as those in The Doni Madonna and The Deluge . . ." (Hartt 1968, 148). During the first two decades of the Cinquecento Michelangelo "frequently drew the human figure . . . without contours, resorting only to shading in the leadpoint to indicate . . . swelling and subsidence . . ." (ibid.). In The Rebellious Slave "the muscles are no longer . . . separated, but flow together in a tide which . . . obliterates the boundaries between leg and torso or torso and arm" (ibid.). In the Giorno "the . . . back . . . is roughly partitioned into . . . masses whose surge is not canalized by any . . . linear contours save those of the twisted shoulder . . ." (op. cit., 190) (fig. 15). Generally, in the Medici Chapel "the . . . muscles seem to flow into each other" (Tolnay 1948, 45). The late Michelangelo in his drawings "dissolves all solid forms" (Hartt 1964, 56), "contours . . . merge with the atmosphere" (Hartt 1970, 309), are "soft and vaporous" (op. cit., 324).

While thus "the phenomenon characteristic of Michelangelo's figures in his last works" is "the dissolution of the boundaries between one personality and another" (op. cit., 303), earlier he has been sufficiently insistent on precisely these boundaries to make one note "the independent body contour . . . characteristic of him" (Hartt 1964, 70), his "merciless pursuit of the contours" (op. cit., 23). "In none of his paintings does he accept the . . . atmosphere of Leonardo, for example, but always insists . . . on . . . clarity . . ." (Hartt 1974, 412).

As even in the early Michelangelo the contour is already threatened by the urge to merge a figure into a larger whole, it is apt to be emphatic. Thus, in Hartt no. 3 "the contour was *reinforced* several times," as in Hartt no. 44A. But also "for the artist's maturity and old age" "*multiple* contours" are as characteristic (Hartt 1970, 81) as—we have already learned that—their opposite: it is the middle ground which is lacking. In a compromise between

16

the desire to merge and the inclination to separate the lines still intended as contours are in their turn separated from the objects whose boundaries they are meant to indicate: "the tendency to detach the contour . . . [from] the forms within it" (Hartt 1970, 270).

Or the contour may become the boundary not between a single object and the rest of the world, but rather a demarcation comprising a plurality of objects—*just as the child's separating himself from the entire non-I is probably preceded by his doing so for the compound formed by himself and his mother.* In Hartt no. 429 "the contours reach out around the three figures [the crucified one, his mother and his beloved disciple]."

The desire to merge and the urge to separate are combined when figures close to each other are yet divided by contours. In The Doni Tondo a "highly compressed grouping . . . the tightly wound knot of arms, legs, and heads" is "defined with . . . precision by . . . sharp, black contour lines . . ." (Hartt 1964, 66–68). In The Conversion of St. Paul there is "a . . . bonding of contours—tangent figures jointed like blocks of ashlar. Surely the tightest seam in the history of painting runs between those two at the right . . . the brazen giant and . . . the turntail with the trailing left leg. The interface dovetails . . . from head to heel . . ." (Steinberg 1975a, 36)—but there is also a "neighboring of overcrowding with desolation" (op. cit., 19).

Not only does Michelangelo's characteristic compactness of composition evoke the marble block in which container and contained merge, that compactness also entails closeness between the several figures within a composition (recall The Bathers of Cascina—*a closeness perhaps as obscurely satisfying as his sharing a bed with three assistants in Bologna 1506–1508, much as he complained about this as due to circumstances beyond his control and which may indeed have played a facilitating role.* In the late Hartt no. 429 showing the crucified Christ with the Virgin and St. John, "in an unprecedented manner the three have . . . drawn close to each other." The urge to unite may also be expressed, as

17

in Hartt no. 58, by "the extension of the hand of one sketched figure onto the shoulder of the next . . . [one kind of] connection between . . . motives that . . . recurs in the early studies."

For any single figure, Michelangelo is apt to limit the voids within it. "Michelangelo never did plan outstretched arms in sculptures . . ." (Tolnay 1948, 146). There is in Hartt no. 9 "the characteristic rubbing together of the Virgin's knees (like the knees of the . . . Crucifix in S. Spirito (fig. 16) or The Dying Slave . . .)." Michelangelo may have chosen the Y-shaped cross repeatedly because it "enabled him to produce a form more compact than that provided by the customary widespread arms of the Cross" (Hartt 1970, 216). With time, the internal compactness of figures grew. In the Moses "the masses have been more densely grouped [than in an earlier drawing] in order to . . . minimize . . . openings" (Hartt 1968, 152); in The Last Judgment "the bodily movements [are] more inhibited . . . compact than in the drawings for the Sistine Ceiling . . ." (Hartt 1970, 265).

But if members of the body may be distinctively joined, architectural members may be as conspicuously broken: pediments and arches in the Medici Chapel and the Laurentian Library.

In his major vein Michelangelo presents figures which are complete. But in a counterpoint he renounces the integrity of the body in favor of a merging with others, as in the "tangle of arms, legs . . . bodies" (Hartt 1974, 456) of The Brazen Serpent (fig. 17). In a preparatory drawing, Tolnay no. 266 r, "numerous barely sketched figures form . . . a nebulous [entity] . . . a tangle." The environment with regard to which a human is a fragment may not be human itself: in The Battle of the Centaurs Michelangelo "differs from his predecessors in that he . . . never detaches the figures completely from the original block; the heads, arms, and legs, even in the foreground, remain connected to the rough-hewn background" (Tolnay 1975, 6): a *finito* equivalent of the *nonfinito* (see above). "Only one figure emerges . . . free of the . . . block— 'Theseus'" (Weinberger 1967, 43). In architecture several members may share a part of their bodies. In The Medici Chapel "the columns and brackets are joined at the corners where, as Acker-

18

man put it, they . . . mate" (Hibbard 1978, 140); rather, fuse (fig. 18).

When, on the contrary, the wish for separateness prevails, the capacity of a figure to exist by itself—not to be incapable of surviving by its own resources, as Michelangelo feared for himself (chapter 3)—may be expressed by a pose in which it might fall, but does not. The Bacchus, so far from falling, serves as support for the little satyr. "The young god is dancing . . . or is he stumbling? . . . His step can no longer be mistaken for that of a dancer; a tendency to stumble forward is only just overcome . . ." (Weinberger 1967, 63–65). (See also Tolnay no. 265). In Michelangelo's architecture in S. Lorenzo "the membering gets heavier as we go up, in contrast . . . to the laws of gravity . . ." (Hibbard 1978, 133).

But in his old age Michelangelo, instead of celebrating the capacity of a figure to stand arduously by itself, accepts collapse, in the Christ of the Pietà in Florence and in the Saint Paul of the Pauline Chapel: "The pose of Michelangelo's Paul is engineered to collapse. . . . Paul's supporting arm is too acutely bent and retracted to steady the toppling . . . torso. . . . The figure turns to us frontally so that its forward falling, accentuated by the . . . helper, is aimed at the spectator. . . . The . . . imbalance and the frontal address are without precedent . . ." (Steinberg 1975a, 38). While the head of Christ on the cross is erect in Hartt no. 408 (1538–1540?) and even in no. 410 (1555–1640?) as well as no. 416 (1545–1560), it falls forward in nos. 421, 423, 430.

If Michelangelo's representations of the Madonna with the child may be related to his *perceptions* of his own mother and nurse (chapter 1), they may also express his *reactions*, then and later, to these perceptions.

Faced with a mother who *perhaps separated herself from him early* and brusquely by being absent, turned toward younger siblings, unloving, and then dead; faced with a nurse who finally consented (or worse) to cease being with him; faced with *what he may have obscurely felt as abandonments by his father surrendering him to Lorenzo* and by Lorenzo dying so soon—faced

19

with all this he *probably was moved to transform passivity into activity, to leave instead of being left.*

"The disposition of the child between the knees of the Virgin" in The Bruges Madonna (fig. 3) "suggests his being in the . . . womb" (Tolnay 1947, 99); "at the same time . . . [he seems to be] about to free himself . . . descend into life" (ibid.): Michelangelo's characteristic simultaneous adoption of even manifestly opposed stances, here both the fulfillment and the renunciation of his desire for oneness with mother. "Still holding her hand, [he] ventures forth with one foot" (Hartt 1974, 418). The moment the child leaves the womb, Michelangelo may be conveying, he acquires the capacity to be by himself (chapter 3); the protracted period during which the infant and small child cannot live without being close to his mother may be denied by the young Michelangelo who endows the Child with a "herculean" body—and makes him emaciated only when united with the mother as, in Michelangelo's old age, in The Milan Pietà (fig. 19) (Peto 1979, 196).

Protecting himself against being engulfed by his mother's depression, the child may diverge from the Madonna's gloom; smiling, for instance, in The Pitti Tondo, which the mother never does.

The Madonna, we have seen, is little interested in the child: then he won't be concerned with her either. Having nursed—or instead of drinking—he falls asleep: The Virgin of the Stairs presents the "Virgo lactans, but . . . the Child has fallen asleep . . ." (Hibbard 1978, 13). While in The Pitti Tondo the mother "gazes into the distance," the child "contemplates . . . the open pages" of a book which he himself "props open" (Hartt 1968, 124).

Or even the mother's interest in her child is not reciprocated by him (Tolnay nos. 240 and 242).

It is not the child who clings to a reluctant mother, it is she who hangs on to a leaving child. One may perceive in The Bruges Madonna "the child's struggle to free himself from his mother. Only her . . . grasp prevents her son from slipping . . . away from her" (Mancusi-Ungaro 1971, 44). In the so-called Manchester Madonna sometimes attributed to Michelangelo "is the boy climbing up or stepping down, backwards? Reaching up, his hand would

20

be missing its aim as it passes between two pages [of a book]. More probable that the hand lay on the page expounding what is to come—and is now sliding down. The first part of the prophecy is about to be realized: let the page turn. . . . The boy's left hand does not clutch at the mother's breast to facilitate climbing, but is . . . disengaged by grasping a fistful of its own garment. . . . What we initially read as an upward tread tending inward becomes a step down, away. . . . The mother-son group . . . foreshadows a separation, . . . to which the Virgin . . . gives melancholy consent" (Steinberg 1980a, 444).

The Doni Tondo presents the Holy Family as a compact group while, unnoticed by them, the little St. John is leaving. *Perhaps Michelangelo saw himself here obscurely as "unnoticed by the parental figures . . . engrossed with the other baby . . .*—the foster child in the family of his wetnurse and then again the outsider upon rejoining his parents. . . . John cannot be cast out; he chooses to leave" (Liebert 1979, 496).

Michelangelo may have improved upon his past by denying not only his own pain, but even what gave rise to it, his mother's unfavorable stance toward him, as we have already seen him doing in the late Madonnas who express love for the son (chapter 1).

The original intimacy between the bodies of mother and child may be presented as enduring: boundaries between them may be absent (see above). In The Virgin of the Stairs "a . . . veil falls . . . around her body. It opens at her lap and . . . the child emerges from the cloth as though from the womb . . ." (Tolnay 1947, 75) (fig. 20). In The Last Judgment it is the Virgin who "shrinks into" Christ (Hartt 1964, 138). "The Madonna cleaves to Christ along the whole length of her form" (Steinberg 1975a, 52) (fig. 21).

In The Virgin of the Stairs "the Child . . . is . . . enclosed in the silhouette of his mother" (Tolnay 1947, 75). (See also Tolnay no. 390 r). Similarly, in the Pietà in Rome "Christ's body is no longer in a . . . horizontal position in which the head and legs extend beyond the silhouette of the whole, but the line of his body, broken in three places, is adapted to that of the Virgin and to the folds of the drapery . . . is subordinated to the triangular contour of the group" (Tolnay 1975, 10).

21

In the two Pietàs of his old age Michelangelo imagines a mother with whom he merges.

In one case (that in Florence) the father aids her to unite with her son: "St. Joseph of Arimathia . . . seems to move the body from the side of Mary Magdalen to that of the Virgin. . . . He unites the mother and son . . ." (Tolnay 1960, 87) (fig. 22).

In Tolnay no. 433r "the contrapposto of the figure of Christ is overcome" which "accentuates the weight of his body which slides downward" and thereby Mary's effort to support him. But she does furnish that effort, though "never . . . before [The Pietà in Milan] does the entire weight of her son's body rest in her arms" (Hartt 1968, 291).

In that work it becomes difficult to discern who supports whom: "She seems to rest on him. . . . [He] appears to seek support from her body . . ." (Tolnay 1960, 91).

In the successive stages of The Pietà in Milan there is an increase in both the closeness between the bodies of mother and son and in the degree to which the son's body consists of what belonged to an earlier body of the mother. A breast of hers becomes his head.

The faces and bodies of mother and son increasingly resemble each other both in positions and features (as do the two nude young lovers in the left background of The Doni Tondo; see Blanckenhage 1973).

The son is apt to be "herculean" when his mother is unloving; self-sufficient when she is unavailable to sustain his life (chapter 3). Merging with his mother he becomes emaciated and weak, now resembling her in this also.

The son's death seems to be a condition for merging with his mother: he can rejoin her only in the country for which she left him so soon.

*Probably Michelangelo's unfulfilled desire to remain merged with his mother gave rise to a lifelong yearning not so much to be attached to an other sensed as different from himself, but rather to share substance with an other;* to be with him, in the words of a sonnet to Cavalieri, "two hearts led by one spirit and one

wish, . . . two bodies [which] have one soul . . . that . . . lifts both of them to heaven. . . . Both would wish to have a single end . . ." (Gilbert no. 57, ll. 4–11).

Michelangelo imagines himself an appendage to the other's body. As a silkworm who "its own hide unskins," (see below about flaying) "I'd want to have my fate adorn my Lord, while living, with my dead remains. . . . If only the hairy coat were mine which . . . clasps so beautiful a breast. . . . If I were only each little boot that makes itself his column and his base . . ." (Girardi no. 94, ll. 9–13). To Julius II, "I am to you as the sun's rays are his" (Gilbert no. 6, l. 6).

Or Michelangelo desires mutual metamorphosis between self and other: "lover turns into beloved one" (Gilbert no. 191, l. 12).

With each such transformation "I am no longer I" (Gilbert no. 152, l. 4).

The other's substance which then becomes that of my own self—as the son in the Milan Pietà came to be increasingly made of his mother's—is noble, not vile as is my own substance (chapter 4) from which I can only thus free myself. "A man, a god rather, inside a woman through her mouth has his speech," Michelangelo explains in a sonnet to and about Vittoria Colonna. "And this has made me such I'll never again be mine. . . . O Lady . . . see to it that I do not return to me" (Gilbert no. 233, ll. 1–13). Indeed, "when I was born," I was "a sketch of no account," "to be reborn . . . a thing . . . perfect . . . from you, Lady" (Girardi no. 236, ll. 9–11).

Refused merging, not only am I condemned to remaining vile, I perish, like an infant, unnourished and uncared for. Rejected by the other I am thrown into a "misery *(noia)* that wills I die outside who murders me" (Gilbert no. 120, ll. 14–15). "I could (as soon) forget your name," Michelangelo writes to Cavalieri, "as forget the food on which I live . . ." (July 26, 1533. Ramsden no. 193). Feeling cast out into the world naked and alone, Michelangelo expects and fears disasters, including the supreme one of death (chapter 3).

But merging with an other, losing one's own self, is as threatening of annihilation (Peto 1979, 184) or at least impoverishment as promising of perfection. If the other first allows me to merge

23

with him, and then withdraws that permission—by absence (that is, any reduction of attachment), desertion or death—"I am almost incapable of returning to myself" (Girardi no. 23, l. 7). [I may be incapable of that even when it is I who abandons: "With great delight," thus Michelangelo transforms his last flight from the Duke of Alba's soldiers, "I have visited the hermits of the Spoleto mountains, so that less than half of me has returned to Rome . . ." (letter to Vasari, December 18, 1556. Ramsden no. 426).] "The greater part of me has gone with him," Michelangelo discloses upon Urbino's, his assistant's and housekeeper's death, "nothing but unending wretchedness remains to me" (letter to Vasari, February 23, 1556. Ramsden no. 410). Even an interruption in the presence of others may threaten loss of the self now lodged in them. Refusing an invitation to prolong a customary reunion with his best friends, Michelangelo explains that "every time I see somebody who has some *virtù*, who shows some excellence of mind, who knows how to do or say something in a more skillful way, I am constrained to fall in love with him." But this entails that "I give myself as a prey *(dare in preda)*, that I am no more mine, but wholly his." Thus, "if I . . . were to lunch with you—you who are adorned with *virtù* and *gentilezze* . . . each of you would take *(torre)* a part of me: the musician would take one, the dancer would take another, and in this fashion everyone of you would have his part. Thus, believing that after being joyous with you I would recover myself and find myself again . . . I would have lost myself . . . ; so that for many days I would not know in which world I was." Once more, "everyone of you would take a part of mine, apart from that of which the three of you have already robbed me *(rubato)* . . ." (Giannotti, 68–69). (There is pretense and there are standard themes in this; but also, in my surmise, feeling).

Whichever way I turn, whether separating or merging, annihilation threatens.

24

# CHAPTER 3

# SURVIVING AND PERISHING

MICHELANGELO'S declaration that "I am the man most disposed to loving who was ever born" (Giannotti, 68) hints that the other—in conventional poetic language a "lady"—"won't take fire from me as I from her" (Gilbert no. 171, l. 4); a standard theme which, again, Michelangelo may have meant seriously. The other "took me from myself and did not wish me *(a me mi tolse e non mi volse)*" (Gilbert no. 34, l. 8). This may indeed—I have dealt with it in the preceding chapters—have been Michelangelo's experience with his early persons; an unhappiness which he \*probably chose to continue by imagining and provoking, for the rest of his life.\* In Hartt no. 311 "the passage at lower right is the beginning of the draft of a letter to Michelangelo's young friend Andrea Quaratesi, 'Andrea, have patience. Love me . . .'" Cavalieri's feelings for Michelangelo were less

intense than those of Michelangelo for him. ". . . [Michelangelo's] letters [from Florence, 1533–1534] to Angiolini [in Rome] must have conveyed frequent expressions of anxiety concerning Cavalieri's affection; for the replies invariably contained some reassuring words" (Symonds 1893, v. 2, 144). "I'll say no more," Michelangelo stops himself in a letter to Cavalieri. "Many things that might be said . . . remain unwritten . . ." because they are too delicate for writing? no, "lest you be wearied" (January 1, 1533. Ramsden no. 191). While "the will [of Urbino] is long and full of minute dispositions in favor of his wife and his children . . . Michelangelo is named only as witness and executor without any word of . . . affection. Could Michelangelo have loved Urbino more than he was loved by him?" (Papini 1949, 522). Vittoria Colonna played a more important role in Michelangelo's life than he in hers.

A few weeks after his birth, —to recall events already mentioned—Michelangelo's mother abandoned him, putting him out to a wet-nurse who may have preferred her own children. A normal conduct for the time and the milieu, to be sure. Yet Michelangelo may have reacted to it more intensely than many other infants. Probably at the age of two (Liebert 1979, 467–471) his wet-nurse, *he may have felt, abandoned him when he was returning to his family.* His mother *abandoned him between the ages of two and six, for three newborn siblings.* When he was six, she *abandoned him for death.* When he was fifteen, his father *abandoned him to the ruler of Florence.* "He [Lodovico] arrived in the presence of the Magnificent and was asked whether he would be willing to let him have his son for his own (*concedere il figliuolo per suo*) . . .'' The father "could not refuse (*non seppe negarlo*)" (Condivi, 12). While Michelangelo may have then and even more later welcomed the change, he may also *obscurely have resented the ease with which his father relinquished him.* When he was seventeen, Lorenzo *abandoned him for death.*

*Probably Michelangelo was left with a permanent sense of having been and being *abandoned* by those to whom he was attached, and with an expectation of this continuing to happen.* "I

26

saw him leave who took me from myself and did not want me" (Girardi no. 36, ll. 7–8).

Abandoned, he felt deprived of what was due him: the victim of thievery, *robbed*. The heirs of Julius may appear to him as "those who have robbed me *(chi m'a tolto)* of my youth, my honor and my possessions" (letter to an unnamed Monsignore, October/November 1542. Ramsden no. 227).

*Having repeatedly felt excluded or expelled from a whole to which he wished to become or to remain joined, Michelangelo came to perceive and expect that another such event was or would be taking place;* and, much as he abhorred it, to obscurely contrive its appearance or occurrence. "You have come [from Florence to Rome]," he lets his nephew know when sixty-nine and ill, "to kill me off and to see if I've left anything. . . . You're like your father who turned me out of my own house *(mi cacciò di casa mia)* in Florence" (July 11, 1544. Ramsden no. 244). Michelangelo flees from Rome to Florence in 1506 when he believes that Julius is replacing intimacy by expulsion: he recalls thirty-six years later having written the Pope, "I was turned out of the Palace *(cacciato di Palazzo)* this morning by order of Your Holiness" (cited by Michelangelo in a letter to an unnamed Monsignore, October/November 1542. Ramsden no. 227). The heirs of Julius, he believes, are trying to turn him out of his house in Rome (ibid.)

Warding off the wish to be accepted by those who exclude and expel him, Michelangelo comes to sense himself fated and even (denying the pain of solitude) to prefer "to live apart and be content with one's company" (Hollanda, 12). *Probably wishing to be taken once more into a house and perhaps obscurely fearing then to be once more expelled from it,* Michelangelo, in his travels, was "reluctant to accept hospitality" (Barocchi 1962, note 518). "I have no truck," he writes from Rome to his nephew in Florence, "with any of our fellow citizens nor with anyone else" (August 22, 1550. Ramsden no. 351) (to be sure, also in view of Duke Cosimo's measures against the Florentine émigrés). "I have no

27

friends," he declares already in his thirties, "and want none" (letter to Buonarroto, October 17, 1509. Ramsden no. 51). In his seventies, "I live shut up here [in Michelangelo's house in Rome] . . . all alone" (Gilbert no. 265, ll. 1–2).

Desiring to love and to be loved is to risk incurring damage (with little prospect of gain): "we lose our own hoping from someone else" (Gilbert no. 167, l. 6).

Better to be incapable of attachment to others: "I shall be like ice in fire that . . . does not catch" (Gilbert no. 20, ll. 20–21).

Being attached to myself only, I rob myself when displacing attachment from myself to an other; or he who makes me do it robs me. "How can it be I am no longer mine? . . . Who's robbed me of myself . . . ? (Gilbert no. 8, ll. 1–3). "She has stolen me from myself (*a me da lei fu tolto*) (Gilbert no. 233, ll. 4–6). (Again, a standard theme, but perhaps also one felt by Michelangelo).

So far from my soliciting and their refusing, it is they who are asking for me and I who am rejecting their demand. "His Holiness sometimes annoys and wearies me when he . . . insistently inquires why I do not go to see him" (Hollanda, 22).

The *terribilità* which Michelangelo cultivates deters *them* from approaching him; *a far cry from a neediness which would make *him* beseech them.*

Instead of being "turned out" of his house, it is Michelangelo who does the turning out; *or at least this is what he makes others say while he denies it—with a vehemence which makes us surmise that he also believes it.* "How can you go about saying," he writes his father in his forties, "that I've turned you out? Don't you see what a reputation you give me that it should be said that I've turned you out? . . . I beg you . . . not to take away my reputation . . . by saying that I've turned you out." "For it matters more to me than you think," perhaps because his own view of himself is not so different from that which others supposedly take of him: in the same letter he announces to his father that "I'll try to imagine"—perhaps that comes easy—"that I've always brought shame and trouble upon you . . . always led a bad life

28

. . . done you every possible wrong . . . like the reprobate I
am . . ." (September/October 1521. Ramsden no. 149).

In fact, Michelangelo was given to "turning out," suddenly
and inexplicably to the victim—as being turned out had been un-
expected and unintelligible for him. Michelangelo repeatedly be-
haved in this fashion toward assistants. "As Michelangelo en-
joyed the gossip of l'Indaco and the jokes he often made, he almost
always ate with him; but as he became tired of him one day . . .
he asked him . . . to buy figs; and when Iacopo had left the house,
Michelangelo locked it with the intent, when he returned, not to
open"—as indeed he did not (Vasari, *Life of l'Indaco*, in Barocchi
1962, 208–209). To assist him on the Sistine Ceiling Michelangelo
called several undistinguished painters from Florence: "As the
manner of none of them pleased him, he found a way to make
all of them return to Florence without dismissing them by closing
the door to all and not letting himself be seen" (Vasari, *Life of
Francesco Granacci*, in Barocchi 1962, 229). "Shutting himself up in
the Chapel, he refused to admit them and would not let them see
him in his house" (Vasari, 28).

In still other manners Michelangelo might render himself
brusquely inaccessible. Thus "it was his way . . . to carry on an
almost daily correspondence for some while, and then to drop it
altogether . . ." (Symonds 1893, v. 2, 106). Or he might suddenly
leave a gathering without a word. "Il Piloto [an assistant] was
astonished that you left without saying anything . . ." (letter by
Piero Gondi to Michelangelo, December 12, 1523. Carteggio, v. 3,
3).

*Having experienced successive disasters in his early life, Mi-
chelangelo remained ever ready to foresee or even to perceive
disaster befalling him.*

Unless counteracted at the very beginning, any unfavorable
event may lead to ruin. "I've heard several things from my as-
sistant Pietro which displease me. I'm sending him back to Pistoia
. . . as I do not wish him to be the ruin of our family" (letter to
his father, September/October 1521. Ramsden no. 149).

29

Ruin threatens not only the family, but particularly one who lives with the sense of having lost his home: "I am very troubled by reason of the many things that befall those who live away from home" (letter to his father from Rome, August 19, 1497. Ramsden no. 3).

Thus Michelangelo's affairs do not seem to him endowed with the self-preserving mechanisms of nature where sun and moon "relieve each other . . . so that the world will not be more destroyed" (Gilbert no. 43, ll. 4–6).

When Michelangelo writes his father "don't worry, for God has not created us in order to abandon us" (September 5, 1510. Ramsden no. 53), he fights his expectation of being deserted, he argues against his forecast that "anything might happen to shatter my world *(mi disfar del mondo)*" (letter to his father, December 19, 1506. Ramsden no. 9). In fact, "there are more troubles everywhere than you credit or are aware of. These are the times I have anticipated for some years now. . . . Things might become worse than you suppose" (letter to Buonarroto, September 1, 1515. Ramsden no. 106).

However extended a benign period, it will end in disaster: "After being happy many years, one short hour may make a man lament and mourn" (Gilbert no. 1, ll. 1–2). "From how many snares and meshes . . . a lovely little bird long years escapes, to die more evilly" (Gilbert no. 3, ll. 9–11). "Love . . . has saved me many years, and when I am old gives me the crueller death . . ." (Gilbert no. 3, ll. 12–14). "Love . . . my prophetic mind you shift to even worse from earlier bad" (Gilbert no. 173, ll. 3–4). The forecast of catastrophe may not only be convincing to Michelangelo because of what happened in the first two decades of his life, but also protect against the evils to come: making himself into their "prophet," he becomes less of the victim he also yearns to be (chapter 7).

"Traps fill all the world" (Gilbert no. 95, l. 6). "This is a traitorous world" (quoted by Vasari, 98), "I do not trust a living soul"

30

(letter to Buonarroto, September 1, 1515. Ramsden no. 106); "my soul . . . is saddened by new suspicions every hour" (Girardi no. 22, ll. 27–29).

"Never have I seen a man with a more honest face," Michelangelo observes about an assistant whom he dismisses in the conviction that "he must have set about to deceive me and have done so many times" (letter to his father, February 8, 1506. Ramsden no. 13). "My love . . . promised me relief . . . wished to dispossess (tor) me" (Gilbert no. 34, ll. 1–4).

The most helping friend may turn out to be the fiercest and most dangerous—by virtue of his very closeness—enemy. "Often, in . . . tremendous kindness some attack on my life and dignity is masked. . . . To give . . . [my] shoulders wings, then draw the noose . . . in gradual secrecy. . ." (Gilbert no. 249, ll. 1–6): thus Michelangelo writes to and about Luigi del Riccio one of whose major purposes in life was to be of use to Michelangelo.

Envious colleagues are out to kill him in Bologna (1495) and Rome (1506). He attributes his break with Julius II in 1506 to "the envy of Bramante," "the envy of Raphael of Urbino" and also the Pope's intent "to ruin me" (letter to an unnamed Monsignore, October/November 1542. Ramsden no. 277)—beliefs either dubious or surely wrong.

*The child fearful about the lack of love and care becomes the adult apprehensive about the lack of means of all kinds to ensure survival;* feeling incapable of assuring his life by himself. "I haven't a penny," Michelangelo writes to his brother from Rome at the time of the triumphal completion of the Sistine Ceiling, "and am, so to speak, barefoot and naked" (September 18, 1512. Ramsden no. 81): behind the glorious nakedness of Michelangelo's figures, showing the power of the male body, there is the miserable nudity of their increasingly wealthy creator imagining himself "struggling against poverty" (letter to Fattucci, October 24, 1525. Ramsden no. 174), "poor" (Gilbert no. 265, l. 2).

When Michelangelo does not already, in his perception, suf-

31

fer from a lack of resources, he may foresee that he soon will: "I am on the highway to ruin (*mi son messo in una cosa da impoverire*) . . ." (letter to Buonarroto, April 2, 1518. Ramsden no. 120).

Death from hunger never ceases to seem plausible to the rich *divino.* "Because of the dearth . . . here. . . , unless . . . assistance is forthcoming, I make no doubt that we shall all die of hunger" (letter to his nephew, March 7, 1551. Ramsden no. 360); he had written the same sentence a week earlier (Ramsden no. 359). In fact, if something unexpected had not occurred, he would by now be dying from hunger: "such was the reward I received for my pains from Pope Julius . . . that were it not for what I have received from Pope Pagolo, I should be dying of hunger today" (letter to an unknown Monsignore, October/November 1542. Ramsden no. 227). (One chooses one's exaggerations.)

It needs only a mistake in the management of his funds, and he will die. "I have little capital here, and if I were to spend that little in Florence, I could die of hunger here" (letter to his nephew from Rome, February 15, 1550. Ramsden no. 344).

Thus, without aid from outside myself, I am lost. "How will I ever dare without you, my beloved, to keep alive?" (Gilbert no. 12, ll. 1–2). If I cease being attached to you, I die: "if he [Cavalieri] were to fade from my memory, . . . I should . . . fall dead" (letter to Sebastiano, August 1533. Ramsden no. 194). "Leaving you, I kill myself" (Girardi no. 80, l. 14); leaving me, you kill me— and, as we have already learned, Michelangelo expects to be left.

Fighting his sense of incapacity to take care of himself, Michelangelo may attribute such a belief to others and deny it. "Look after yourself," he urges his nephew at eighty-eight, "and don't worry about my affairs because I know how to look after myself . . . and I am not an infant (*putto*)" (August 21, 1563. Ramsden no. 479).

Michelangelo is apt to have sensed a sameness between himself and "the poor ashamed to beg," principal object of his charities. "I'm thinking of making a will he discloses to his nephew.

. . . If you remain without legitimate issue . . . the income will be given . . . to those ashamed to beg *(vergognosi)* . . ." (letter to Lionardo, February 20, 1552. Ramsden no. 368).

Dreading as well as cherishing his sense of depending on the resources of others for surviving and succeeding, Michelangelo demonstrates his self-sufficiency in creating by the novelty and scope of his work—while at the same time accenting the limits to his capacity by the recurrent discrepancy between projects and realizations (chapter 5).

He is inclined to refuse—or to imagine doing so—customary kinds of assistance in his work, expecting that this will make others—or * himself?—* believe that it is not he who creates. "He finished," he probably told Condivi about the Sistine Ceiling, "this entire work . . . without any help whatever, not even someone to grind his colors . . ." (57–58).

Choosing a modesty in consumption resembling that of his foster parents, Michelangelo strives to be one "who grows by lacking," to "be so moderate as to ask nothing of you" (Hollanda, 13); in particular, to "hold" himself "back" from "delights" such as "food *(vivende)*" (Girardi no, 67, l. 44) unless seduced by a seemingly reliable caretaker (Luigi del Riccio offering delicacies in exchange for poems). "Fortune, however ill, against one flying lowly cannot . . . boast of a great collapse. With what a kind good will poverty . . . scourges me gently . . ." (Gilbert no. 242, ll. 7–12). The Children's Bacchanal shows a community of putti bestowing on themselves the pleasures of food, drink, sleep and elimination independent of the indifferent, incapable and disgusting adults shown beneath them (fig. 23).

Just as Michelangelo seems to have regarded oral frugality as a means for amassing a protecting fortune rather than spending it, he may have considered genital abstinence—Condivi reports "his continence with regard to intercourse and food" (108)—as a means for amassing a death—averting force rather than drawing on it.

"Throughout his life he accumulated property . . . continually buying farms and houses" (Tolnay 1947, 8); as well as luxurious clothing, discovered in vast quantity and variety in his house upon his death (Barocchi 1962, 1848–1849). These hoards were not for use: he was famous for his simple and worn clothes. While he might have repaid his creditors in the affair of the tomb of Julius II by the sale of a part of his holdings, he found it difficult to do so (chapter 4). *Probably his hoards had to remain untouched to give permanent evidence that he was no more a resourceless child at the mercy of unreliable caretakers.* He deserted his important military responsibility in Florence under siege so as to save his liquid funds (carried with him) from being subject to a forced loan to be imposed by the Republican Government. When Michelangelo recurrently in conversation and correspondence discussed the comparative importance of life and possessions, he was *probably considering the respective risks of death by destitution and by violence* (apart from expressing—mainly by opposing—his obscure attachment to possessions in themselves: a matter on which I shall not elaborate).

*Probably continuing to yearn obscurely for gifts as tokens of a love which does not need to be solicited as well as tokens of the availability of supplies, which need not be under one's control to be dependable, Michelangelo is determined to rely only on that over what he is master.* "I've received," he writes his nephew in a frequently adopted vein "a packload of trebbiano for which I am grateful. Nevertheless, I tell you not to send me anything else unless I . . . ask you for it, because I'll send you the money for what I want" (letter of June 1548. Ramsden no. 308). When the Pope offers him an honorarium for directing the work on St. Peter, he points out—refusing—that "I would have asked for it had I needed it" (quoted by di Maio 1978, 358).

So far from gifts being precious, they are useless. "Lionardo," Michelangelo addresses his nephew, "I have received three shirts together with your letter and am very surprised that you should have sent them to me, as they are so coarse that there is not a peasant in Rome who wouldn't be ashamed to wear them." In any case, "had they been finer . . . I shouldn't have wanted

34

you to send them, because when I need any I will send the money to buy them" (letter of July 10 or 17, 1540. Ramsden no. 203). "Lionardo," he repeats years later in response to the same conduct which he has been unable to discourage, "I've had the shirts . . . I'm very grateful for them. But all the same I don't like taking them from you because I don't lack for anything" (letter, August 5, 1553. Ramsden no. 384): *so strong are Michelangelo's fears of being unable to provide for himself and his desire to be provided for that they are apt to be aroused by any gift.*

In addition, gifts increase the claims on Michelangelo's insufficient (as he perceives them) resources by creating obligations. "A gift . . . leaves another fettered. . . . So my freedom . . . weeps more [at receiving it] than at being cheated (furto)" (Gilbert no. 250, ll. 1–6).

Yet all these efforts of Michelangelo's to be self-sufficient are outweighed by *his sense that so as not to perish he must become the charge of dedicated males—women have failed him—who will sustain his life by feeding him, caring for him, supplying him with the resources for living and working: life-sustainers (Liebert 1983, 152), exalted and humble, servants and popes.* "I need to be looked after," he wrote in his thirties to his father, when reporting the defects of a servant (February 1513. Ramsden no. 90). *Probably not only because of his absorption in work, but also because he needed and yearned to become and remain in adult life what he may have sensed not to have been in his early days: the exclusive, permanent, effective concern of caretakers.*

One such was Luigi del Riccio who nursed Michelangelo through two grave illnesses in his apartment, and sent his abstemious ward delicacies for the mouth as the price for poems in praise of an adolescent del Riccio loved. "If ever it was difficult . . . to induce him to do anything," the agent in Rome of the Duke of Parma and Piacenza wrote to his master about Michelangelo, "it is now that Messer Luigi is dead who used to manage him . . ." (November 1546. Quoted by Ramsden 1963, v. 2, 250). "Now that Luigi del Riccio is dead, who did all practical things for him (governare tutte le sue cose)," wrote the Treasurer-General of the Vatican to the same Duke, "he appears to be stunned so that he does

35

not know how to do anything but to surrender to despair" (November 13, 1546. Quoted by Steinmann 1932, 28).

There was Urbino, stone mason like the father and husband of Michelangelo's wet-nurse. "While living he kept me alive" (letter to Vasari, February 23, 1556. Ramsden no. 410). When he dies after many years of sharing Michelangelo's lodging, Michelangelo, in a sonnet, sees him in heaven where "he awaits that I may share his lodging" (Gilbert no. 298, l. 14); *he* will never abandon. When in 1552 Cellini, acting on behalf of Grand Duke Cosimo, visits Michelangelo and presses him to come to Florence, "he [Michelangelo] turned to his Urbino as if he were asking him what he thought of that. This Urbino of his immediately . . . loudly spoke thus: 'I will never leave (*spiccare da*) my Messer Michelangelo, until I shall have flayed (*scorticare*) him or he me . . ." (Cellini, 240). (For what flaying meant to Michelangelo, see chapter 5.) "When Michelangelo fell ill," Daniele da Volterra writes soon after his death about his last days, "he had me called. . . . When he saw me he said: 'Oh, Daniello, I am finished . . . don't abandon me *(non mi abbandonare)*.' And he made he write a letter to his nephew Lionardo asking him to come. He told me to wait for Lionardo in the house and not to leave for the sake of anything" (letter to Vasari, March 17, 1564. Quoted in Barocchi 1962, note 696).

Not only will the caretaker in contrast to Michelangelo's early persons never abandon, he will, in the same opposition to the past, be highly effective in procuring satisfactions for Michelangelo who in a sonnet describes the conduct of one such (Luigi del Riccio): ". . . the great gift and the kindness, the food, the drink, the traveling so often, meeting and satisfying all my wants . . ." (Gilbert no. 297, ll. 9–11). "Lionardo," Michelangelo writes to his nephew, "Urbino is . . . in a very poor condition. I do not know what will ensue. I am upset about it as if he were my own son, *because* he has served *me* faithfully for twenty-five years and as I am an old man I haven't time to train anyone else to suit *me*. I am *therefore* very grieved" (November 30, 1555. Ramsden no. 407). "I have had him," Michelangelo writes after Urbino's death, "twenty-six years . . . ; and now . . . that I expected him to be

a support . . . in my old age, he has vanished from me . . ."
(letter to Vasari, February 23, 1556. Ramsden no. 410).

The caretaker, as I have already surmised, prevents catastrophe by which Michelangelo, feeling abandoned, may have sensed himself threatened in early life. In Michelangelo's work in old age "one motif . . . assumed overwhelming importance . . . : the servant or friend bending over to help. . . . Think him away and . . . Paul [in the fresco in the Pauline Chapel] lies abandoned; not only because Paul's . . . support is withdrawn, but because . . . the knot of figures at his back intervenes to divorce him from Christ. . . . The helper's posture consummates the reach of Christ's arm and his yellow tunic brings the light of Christ down to the Apostle. . . . Even the foreshortening of this agent of charity resembles Christ's . . ." (Steinberg 1975a, 26). (fig. 24)

The caretaker, Michelangelo will insist, views himself mainly as an instrument for Michelangelo's welfare. "More than dying, what he regretted," Michelangelo affirms about Urbino, "was to leave me with so many afflictions in this treacherous world . . ." (Vasari, 98) (*This is what *I* most regret about his death?)* Thus Michelangelo's childhood, in which he may have sensed his early persons loving themselves more than him, stands corrected.

Michelangelo, in turn, makes his attachment to a caretaker depend on the usefulness of that other to him. Writing to Urbino's widow a year after his death, he notes "the love I still have for Urbino, *although* he is dead . . ." (April 28, 1557. Ramsden no. 431).

Whoever is a not inadequate caretaker becomes highly charged: Michelangelo leaves the Milan Pietà to Urbino's successor.

Besides the butlers and the managers there are the patrons: Lorenzo, Aldobrandi, Riario, Galli, the Signoria and especially Soderini, Julius, Leo, Clement, Paul, to stop at Michelangelo's old age. To be sure, Michelangelo would have needed them for his work even if he had not entertained the feelings I have surmised. But when he recalls to Julius that "I hoped your height would let me rise" (Gilbert no. 6, l. 9), he probably thinks not only of the commissions that Pope awarded and only he would offer, but also of the closeness and admiration he bestowed—which Mi-

37

chelangelo had probably never received from his father and which, he may have felt, would enable him to attain excellence.

While pleasing the patron holds out the hope of fulfillment, displeasing threatens ruin. Hence "I am never disposed," Michelangelo protests to a friend acting as middleman between him and Clement, "to depart from the will of the Pope—provided that I comprehend it . . . I beg you to write and tell me what the Pope's wishes are that I won't contravene them, and I beg you to find out from him and to write and tell me on his behalf so that I may the better and more readily obey . . ." (letter to Fattucci, November 1, 1526. Ramsden no. 178): words not only proper, but, in my surmise, also felt (chapter 7).

Yet Michelangelo's hope for a patron who would not cease to supply him with all that he himself lacks remains unfulfilled (Liebert 1983, 360): either the patron dies; or his resources turn out to be insufficient for Michelangelo's needs; or they decline; or—worst and most expected by Michelangelo—his reactions to Michelangelo become less favorable: "those who can don't wish" (Gilbert no. 6, l. 2). Perhaps by Michelangelo's own doing, despite his resolve to please, which may only make matters worse: "I have pleased you," he addresses Julius, "less the more that I have labored" (loc. cit., l. 8).

*The sense of a gap between needs and resources, established in infancy, cannot be bridged.

# CHAPTER 4

# BESTOWING AND ROBBING

*OBSCURELY BELIEVING that his early persons had withheld what was due him, Michelangelo (as we have already learned) remained sensitive to any indications that the same was happening to him in adulthood, and was apt to hold this to be the case when observers might not perceive it.*

Michelangelo fled Florence in 1529 to save his liquid wealth from a probable forced loan to the Republic of which he was a major official. Then he returned and became subject to such a measure intended to finance the military defense against the Papal-Imperial attack on behalf of the Medici. The attack succeeded, and Michelangelo narrowly escaped death at the hands of the victors. He thereupon proceeded to press (successfully) the new regime—which was executing his friends—to reimburse a "loan" made to its overthrown predecessor by one of its partisans so as to enable

39

it to repel those now asked to repay this debt (Barocchi 1962, 1045–1046).

While I demand nothing but what is due me, I insist on receiving precisely that, reject any substitution, also one of higher worth: even then, presumably, the original injury would be repeated rather than undone. When first one papal revenue allotted to Michelangelo (that from the ferry over the Po at Piacenza) was withheld from him, and then another (that from the chancellery in Rimini), Michelangelo reacted with a degree of distress only equaled by what he felt at certain moments about the project of Julius' II tomb, and rejected a compensatory payment offered him. He may well have exaggerated the Vatican's injustice and insult, and underestimated its externally caused difficulties.

Michelangelo would press for what was owed him even when he did not believe in the success of his effort: *he would in any case show once more that he was being unjustly deprived.* "Lionardo," he writes his nephew, "it would be to my advantage to have the two briefs of Pope Paul [now dead—NL] in which his Holiness grants me a salary for life . . . which briefs I sent to Florence with the other documents in the box you received. . . . If . . . you can send them . . . I wish to show them to the Pope so that he may see that . . . I am his Holiness' creditor . . . for more than two thousand scudi; not indeed that it will be of much avail to me to do this, but it would give me satisfaction" (August 7, 1550. Ramsden no. 349). "The briefs," he informs his nephew a few weeks later, "have come according to which . . . I am owed more than two thousand gold scudi. I don't know what will ensue. I have no hope . . ." (August 31, 1550. Ramsden no. 352).

In one belief of Michelangelo's, then, he is incapable of procuring from the depriver what he withholds. "Lady," Michelangelo admits, "up to your . . . crown . . . none can attain, without your adding your . . . grace. The climbing stiffens and my strength runs down, and by the halfway point I am out of breath. . . . To revel in your loveliness I long for your descent where I can reach. . . . [I] . . . hate your high state, love the lower . . ." (Gilbert no. 154, ll. 1–14), which can be produced—just as man's

40

justification, according to the belief to which Michelangelo became attracted—only by the other's grace, not by one's own works.

While such lack of power is dismaying to Michelangelo, it may also reassure. *For he seems to obscurely perceive in himself a combination of power and greed—desire exacerbated by frustration—which would make him seize, *rob* what is withheld, and in so doing damage/destroy the withholder.* In the Sistine Ceiling "Ozias is feeding avidly from the breast of his mother whose . . . strength seems to be thereby absorbed. . . . The woman who has delicate and dolorous features and a fragile body . . . seems exhausted, her face is pale and her eyes are closed. . . . In her left hand is what seems to be a . . . loaf of bread . . . a probable allusion to . . . [the child's] huge appetite" (fig. 25). Now "[this] suckling child assumes the very same pose as . . . Adam in the Fall above this spandrel" (Tolnay 1955, 181), Adam who "stretches forth his arm to take the fruit. The greediness of Adam is expressed in his features—his aquiline nose, his . . . lips and his gestures. He grips the branch of the tree with his left hand while . . . he claws for the fruit with his right. . . . Adam . . . [has] an enormous and coarse body . . . with his legs apart and slightly bent spine . . . recalling an ape rearing on his hind legs" (op. cit., 31) (fig. 26). In the spandrel of Ezekias the woman who "apparently has just given suck to her child" is "of massive build," yet "exhausted": the child is "large and muscular" (op. cit., 82). In yet another spandrel "the children torment their aged mother. One of them . . . clambers onto her back . . . kissing her violently. The other two are crowding between her legs; one is feeding from her breast, while the other sleeps in satisfaction. . . . Joram seems to be the impetuous child on his mother's back. . . . Michelangelo anticipated the evil character of the future king by representing him as a tormenting child" (op. cit., 89).

*Probably combatting his fear and guilt about destroying his mother/nurse by emptying her breast (as well as warding off his fear of dying from hunger (chapter 3): Michelangelo, as we have already learned, was "abstemious . . . taking food more out of necessity than for pleasure" (Condivi, 105–106).*

From these feelings Michelangelo may also present a breast that is forever full, or imagine one against a contrasting reality. In

41

The Last Judgment Ecclesia's "exposed breasts show the abundance of . . . spiritual milk . . ." (Hartt 1964, 136). "When I look upon you and each breast," Michelangelo addresses a hag in a poem, "I am like straw and start to flash. . . . If my . . . cup I still possessed, I'd follow you . . . and if I thought that getting it was possible . . . I would do something incredible" (Gilbert no. 18, ll. 17–24). The incredible does happen, in another poem, to an evil giant: "a . . . old woman upon her milk nurses (*lattare e mammare*) the . . . creature" (Gilbert no. 66, ll. 25–26).

In contrast there is the old woman with dry breasts (see chapter 1): they have become that, Michelangelo seems to insist, by the work not of the child, but of time; the child, he, is not the criminal but the victim.

Feeling himself a victim of withholding, Michelangelo could be intent on not inflicting what he had suffered; as his accounts show, he was meticulous about paying for goods and services bought. I am depriving myself, not others: "I live poorly, but I pay well" (letter to his nephew, August 16, 1550. Ramsden no. 350).

Assuming the role of dutiful son toward his father, of older brother and father toward his brothers, bestowing money and concern on them beyond what may have been viewed as their due, Michelangelo *probably leaned over backward against his urge to seize (rob) what had been withheld from him and to punish those who had deprived him.* At the same time he thus *attempted to reduce his guilt for having surpassed them (Liebert 1983, 35), and showed how he himself should have been treated.*

Michelangelo will, in a rare instance, express his wish to rob from his father only when attributing to his father the wish to rob (and therefore to kill) him as well as the (absurd) belief that he, Michelangelo is out to rob: "If my existence is a cause of annoyance to you, you have found the way to remedy this, and you will inherit the key to that treasure which you say I have. . . . All Florence knows the . . . rich man you were and how I have

always robbed you . . ." (letter, June 1523. Ramsden no. 154): a confession highly deviant from easily visible reality only accents one's virtue (see Michelangelo's letter to Bibbiena, chapter 5).

His father and his brothers (later his nephew), Michelangelo is certain, lack love for him to the extent of being ignorant of everything in his soul and life, viewing him only as an unknown source of benefits. "Buonarroto . . . I don't think you realize how I am living here [in Rome]" (letter, October 17, 1509. Ramsden no. 51). "Dearest father . . . never an hour's happiness have I had, and all this I have done in order to help you. . . . You have never . . . recognized . . . it" (letter, October 1512. Ramsden no. 82). "Buonarroto . . . you have never known me and do not know me" (letter, July 30, 1513. Ramsden no. 92). "There is a giant . . . whose height is such from his eyes down to us he cannot see. . . . His body . . . has just one eye, and that is in one heel" (Gilbert no. 66, ll. 1–8).

Michelangelo responds by both complying and raging.

In letters to his brothers all written in his twenties in the same year, he insists, as though he were combatting an inclination to withhold in his turn, that "I . . . will do what I have promised you without fail" (letter to Buonarroto, January 22, 1507. Ramsden no. 10). "As soon as I come home . . . I am for setting you both [Buonarroto and the addressee] up as you desire. . . . Rest assured that I mean what I say" (letter to Giovan Simone, April 28, 1507. Ramsden no. 23). "The promises I have made to Buonarroto and to you I am prepared to carry out" (letter to Giovan Simone, May 2, 1507. Ramsden no. 24). "Keep up your spirits, all of you, because I will do as I have promised you whatever happens" (letter to Buonarroto, November 10, 1507. Ramsden no. 37).

*Michelangelo's own temptation to replace bestowing by withholding may appear to him as unfounded apprehensions of recipients who add suspicions of his virtue to earlier hostile acts.* "Dearest Father—I wrote to you about doing what I have promised for those brothers of mine and I have not thought better of it . . ." (July/August 1512. Ramsden no. 78). Ten years later, and again to his father, "do not be in any way upset by what I write, for I am disposed towards every one of you as I have always been" (March 8, 1522. Ramsden no. 59). A quarter of a century

43

later to his nephew, "you have been mighty quick in giving me information about the Corboli properties. . . . Were you afraid, perhaps because it was put into your head, that I might change my mind?" (February 6, 1546. Ramsden no. 262).

*So far from disappointing, as I was disappointed, I shall surpass even your exacting expectations:* "There is something greater—or rather, better—in store for you than you think" (letter to Giovan Simone, May 2, 1507. Ramsden no. 24).

In fact, I shall satisfy *all* your wishes (as Michelangelo obscurely may have continued to believe beyond early childhood that all his wishes could only—and should—be satisfied by others: chapter 3). "Buonarroto arrived," Michelangelo writes to his father from Rome. "He . . . will lack for nothing as long as he likes to stay. . . . I'll not let him lack for anything" (August 19, 1497. Ramsden no. 3). To his nephew more than half a century later, "Lionardo . . . a letter for Gismondo will be enclosed with this. . . . He shall not want for anything" (July 15, 1555. Ramsden no. 404).

Even if he loses everything, a possibility which haunted Michelangelo (chapter 3), "If she," Michelangelo writes his father about a suing relative, "were to take away everything you have in the world, you would not lack the means to live and to be comfortable if there were no one else but me" (January 27, 1509. Ramsden no. 45).

I protect and gratify you at unlimited cost to myself. I do nothing but deprive myself—for the major or even sole purpose of benefiting you. *When I was a child, you deprived me for your own sake; now I deprive myself, still for your sake.* "I want you to realize," Michelangelo writes to his father, "that all the toil and sweat I have continually endured has been no less for your sake than for mine and that what I have bought, I have bought so that it might be yours. . . . Had it not been for you I should not have bought it" (June 1509. Ramsden no. 48). "For twelve years now I have gone about all over Italy, leading a miserable life; I have borne every kind of humiliation, suffered every kind of hardship, worn myself to the bone with every kind of labor, risked my life, my very life, in a thousand dangers, solely to help my family . . ." (letter to Giovan Simone, June 1509. Ramsden no. 49). "I

44

have no money. This which I am sending you is of my life's blood . . ." (letter to his father, February 1513. Ramsden no. 91).

Only rarely does Michelangelo cease to recall to his family that he is suffering for them. "As to Gismondo," he writes Buonarroto from Rome in one such moment, "I learned that he is coming here to expedite his affairs. Tell him for me not to place any reliance on me, not because I do not love him as a brother, but because I cannot help him in any way. I am obliged to care for myself before others . . . I am living here in a state of great anxiety and of the greatest physical fatigue; I have no friends of any sort and want none. I haven't even time enough to eat as I should. So you mustn't bother me with anything else, for I could not bear another thing" (October 17, 1509. Ramsden no. 51).

On the other hand Michelangelo may declare himself ready to assume extreme cost on behalf of his relatives where it is not clear how such a sacrifice might be required, except as punishment for bad wishes and deeds (such as that of surpassing them), or as gratification of unacceptable desires. "Buonarroto, I learned from your last letter that Lodovico has been at the point of death but that at last . . . he is out of danger. . . . If there were any danger, I should want to see him . . . before he died, if I had to *die with him*" (November 23, 1516. Ramsden no. 133). "What you ask of me I'll send you," young Michelangelo writes his father, "even if I should have to *sell myself as a slave*" (August 19, 1497. Ramsden no. 3) (chapter 7).

Some of the hostile feelings toward the family which Michelangelo thus keeps in check break through when he reproaches the recipients of his beneficence for their real or imagined ingratitude: *a reaction of theirs which probably both reduces Michelangelo's guilt about his hostility to them and enhances it, as he may sense that very hostility to have been perceived by them behind his good works.*

You don't even notice my sacrifice (and *thus show how justified my bad feelings toward you are; feelings on which I would acquire the right to act on the ground of your very ingratitude to my leaning over backward against them):* "I lead a miserable existence. . . . Thus have I lived for some fifteen years now and never an hour's happiness have I had, and all this have I done in

45

order to help you, though you have never . . . believed it . . ."
(letter to his father, October 1512. Ramsden no. 82). But then "you
have never known me and do not know me" (letter to Buonar-
roto, July 30, 1513. Ramsden no. 92). *You do not love me; hence
I do not need to feel guilty about not loving you either, about not
discharging my obligation to love you by the benefits I am be-
stowing on you beyond obligation.* You merely know how to
demand ever more benefits (what Michelangelo *probably ob-
scurely thought of his own greed toward his mother/wet-nurse).*
"Buonarroto, I haven't time to answer your letter. . . . I . . . will
do all I can for you. I work harder than anyone who has ever
lived. I am not well and worn out with this stupendous labor and
yet I am patient in order to achieve the desired end [to benefit
you]. So you too can very well be patient . . . being ten thousand
times better off than I am": (letter to Buonarroto, July 24, 1512.
Ramsden no. 77) it is not I who am enviable, having surpassed
you, and has to feel guilty on that account; it is you who are
enviable because of all I do for you and who should feel guilty for
what that costs me. That you don't exonerates me even more.
When his father is dead and he, Michelangelo, alive, he insists
that it is his father, not he, who should feel both enviable and
guilty because he is responsible for Michelangelo's dismal condi-
tion: "Since Heaven has now removed you from our burden, have
some regret for me who am dead while living, since through your
means it wished me to be born. You're dead . . . I hardly write
it without envying . . ." (Gilbert no. 84, ll. 43–48).

But then—Michelangelo's hostility breaks through on rare oc-
casions—I am putting myself out not for your sake, but for my
own: so as to avoid feeling bad if I abandoned you—despite
everything which would justify that. Thus what *you* are and do is
not pertinent: "I'll always do what I can for you, because I care
more about fulfilling my obligations than about the things you
say" (letter to Giovan Simone, 1531. Ramsden no. 185). "Dearest
Father—I learned from your last letter about the farm you have
got from Santa Maria Nuova. . . . Although it is expensive, I as-
sume you saw that it was worth it. . . . Now only one thing more
remains for me to do, and that is to set up those brothers of mine
in a shop, for I think of nothing else day or night. Then, it seems

to me, I shall have discharged my obligations; and if more of life remains to me, I want to live it in peace" (June 5, 1512. Ramsden no. 76): *oblivious of you? vainly wishing to break a bond which I sense as unbreakable?*

Giving in the face of such reluctance and for such an end, Michelangelo insists on it being conspicuously clear that he *is* giving. "Giovan Simone—this morning . . . I've paid to Bartolomeo Angiolini six hundred and fifty gold scudi in gold which he will remit to Florence to Bonifazio Fazzi for the redeeming of the farm at Pazzolatica. . . . I should like it always to be clear for the benefit of whomever survives me that the said money came from me. So I should like you to talk it over with Bonifazio and if this is legal get him to enter it in such a way that it will always be clear that it came from me" (August 7, 1540. Ramsden no. 204).

If one of Michelangelo's motives in conferring benefits was to weaken guilt, he might also abstain from depriving not for the sake of the victim, but so as to avoid the burden of repairing, or the guilt about failing to do so. "I do not want him to stand a loss or to suffer on my account, because I do not want to be beholden to anyone" (letter to Buonarroto, October 6, 1515. Ramsden no. 109). "I do not want to impose on Pier Francesco Borgherini nor to bother him in any way, because I want to be under as little obligation to him as I can . . ." (letter to Buonarroto, October 20, 1515. Ramsden no. 110).

The Michelangelo who strives to fulfill obligations is also the Michelangelo who perceives and expects others to violate theirs.

Michelangelo was sensitive to the possibility and actuality of others delaying or even defaulting on the delivery of money, services or goods which they had obliged themselves to furnish at a certain date. *Probably such prospects or events, which may well have been grave in their own right, in addition, obscurely aroused extreme feelings about early persons.* When Michelangelo's father has delivered the purchase price of a farm to the head of the hospital of Santa Maria Nuova, but has not yet obtained possession of the property, Michelangelo suspects the worst: "My revered father—I learn from a letter of yours that the Spedalingo has not

returned to Florence and, consequently, that you have not been able to settle up about the farm. . . . I . . . am much worried about this . . . : I am wondering whether the Spedalingo did not go away on purpose in order not to have to relinquish the income from it, but to retain both the money and the farm" (January 31, 1506. Ramsden no. 6)—an equivalent to the conduct which the heirs of Julius II were to attribute to Michelangelo; and which he himself also suspects in a marble cutter of Carrara: "Baldassare— I am very surprised at you. Since you wrote me such a long time ago that you had so many marbles ready, since you've had so many months of wonderfully fine weather for sailing, since you've had of me a hundred gold ducats . . . I do not know how it comes about that you do not serve me. Will you please ship the marbles you told me you had ready immediately . . ." (October 1512. Ramsden no. 84). Similarly in the quarries within the domain of Florence: "I have had an answer from the men at Pietra Santa who undertook to quarry a specific amount of marble some six months ago; they will neither do the quarrying nor return me the hundred ducats I gave them . . . a bold course which . . . they would not have taken without support" (letter, August 1518. Ramsden no. 129)—"Sandro has left. . . . He lived here in style for several months with a big mule and a little one, intent on fishing and philandering. I have thrown away a hundred ducats on him" (letter to Buonarroto from Serravezza, September 2, 1518. Ramsden no. 130)—"The five hundred ducats I've earned in accordance with the agreement [on the Sistine Ceiling] are due to me, and as much again the Pope has to give me to put the rest of the work in hand. But he has gone away and left me no instructions, so that I find myself without any money and do not know what I ought to do" (letter to his father, September 5, 1510. Ramsden no. 53). "Reverend and Magnificent Lord Datary," Michelangelo writes thirty years later to the Vatican's paymaster, "of the regular salary of fifty scudi a month which our Lord grants me, I am owed payment for eight months. . . . Would you be kind enough to pay them to Salvestro da Montaguto and Company for me, and to continue to make them a regular payment month by month. . . . I should be glad if the payment might be made promptly" (letter, October 17, 1542. Ramsden no. 252). This is

48

indeed how the Vatican is likely to have behaved—and *probably in any such situation Michelangelo was obscurely overcome by the certainty, as he might have been when a child, that no supplies would ever again come forth from the source in question;* and felt as unable to survive without them as he had in childhood when he saw himself abandoned (chapter 3).

Worse, as we already know, in Michelangelo's perception and expectation the authority on which work and life depend may brusquely abolish *all* of its relationship with Michelangelo (*as, he may have felt, the persons of his childhood did repeatedly).* Thus, in the early spring of 1506 the Pope not only made himself inaccessible to Michelangelo with whom he had developed what seemed to Michelangelo a close bond, but also cut off Michelangelo's absorbing work for his tomb.

The dispensing one may act against me without informing me: *probably as in childhood.* "At table on Holy Saturday," Michelangelo tells Giuliano da Sangallo about the event just mentioned, "I heard the Pope say to a jeweler and to the master of ceremonies . . . that he did not wish to spend one *baiocco* more either on small stones or on large ones. At this I was much taken aback" (May 2, 1506. Ramsden no. 8).

Such a cut-off may have seemed inexplicable to Michelangelo—*as in childhood*—and may have remained unexplained: "March 10, 1520: contract for the facade of San Lorenzo . . . inexplicably annulled . . ." (Hartt 1964, 60).

The cut-off may appear as due to an unreasoned change of feeling in the other: *as in childhood. I am not responsible for it; or rather, I fight against the conviction of having caused it by badness.* In 1506, Michelangelo surmised a third of a century later, the Pope simply "changed his whim" (letter to an unnamed Monsignore, October/November 1542. Ramsden no. 227): Michelangelo is going to repay him in kind with regard to his very tomb.

Or is the dispensing one turning away from me to a rival? (The probable antecedents in childhood are evident). Michelangelo attributes the Pope's replacing in 1506 his tomb by the New St. Peter as his main project to Bramante whom Michelangelo also believed to be intent upon killing him.

But cutting off my resources *is* murdering me: "If you sate

the crowd and beasts and I'm denuded, it's murder . . ." (Gilbert no. 144, ll. 3–6).

*Probably Michelangelo was, obscurely, inclined to withhold—both in talion against having been the target of withholding and for the sake of preserving what he possessed in the face of the prospect of perishing from destitution.* But *probably the fear and the guilt aroused by these very motives for withholding made it difficult for him to accomplish it, or made for distress if he did.*

Harboring an urge to withhold, he may feel guilty about not furnishing what it is clearly not in his power to deliver. Buonarroto having asked Michelangelo in Bologna to have a dagger made for a friend, Michelangelo explains that "I have not replied before to your letter, or to Piero Aldobrandini's, because I was unwilling to write until I had got the said Piero's dagger. It is two months since I ordered it from the bladesmith, who has the reputation of being the best master of his craft here, and although he has trifled (straziare) with me all along, I did not want . . . to have it made by someone else nor to take one readymade. However, if . . . Piero feels that I have trifled with him, he has every reason, but I couldn't help it" (March 6, 1507. Ramsden no. 16).

Having withheld, Michelangelo may cease doing so on his own initiative. "Lionardo," he writes in old age to his nephew, "I would like you to search among the papers of . . . our father to see whether there is a copy of a contract . . . drawn up in respect of certain figures which I promised to execute for Pope Pius II [rather: III—]. . . . The said work has been suspended [sic] . . . for about fifty years now, and because I am an old man I should like to settle up the said matter so that after me it may not . . . be a cause of annoyance to you. . . . If the copy is not found in the house, it could be inquired for from the son of . . . Ser Lorenzo. . . . Don't be particular as to the expense in getting a copy of it" (September 20, 1561. Ramsden no. 469). As a conse-

50

quence, "on April 21, 1564, Lionardo paid one hundred scudi to the heirs of Pius III, which had been advanced to Michelangelo in respect of the fifteen statues commissioned in 1501 for the Piccolomini Chapel in Siena . . ." (Ramsden 1963, v. 2, 203).

Michelangelo's great act of withholding occurred not with regard to his father and brothers whom he served beyond duty, nor with regard to assistants and servants whom he often gave more than their due and always that, but in relation to the first Pope for whom he was working, the one to whom he was most strongly and most dividedly attached, Julius II. That Pope, in 1506, started a sequence of events spread over forty years by withdrawing from Michelangelo his person and his means. Michelangelo was then absorbed in the work which the Pope called off brusquely, and inexplicably, or for a reason which added insult to injury (preferring Bramante). Michelangelo fled. Julius coerced him (with whatever initially unacknowledged, but soon manifest willingness on Michelangelo's part) to return to working on the Pope's (now largely other) projects, with repeated delays in payments requiring much effort on Michelangelo's part to obtain his due. "The five hundred ducats I have earned [for The Sistine Ceiling] . . . are due to me, and as much again which the Pope has to give me. . . . But he has gone away and has left no instructions, so that I find myself without any money and do not know what I ought to do" (letter to his father, September 5, 1510. Ramsden no. 53). "When the vault was nearly finished, the Pope returned to Bologna; whereupon I went there twice for money that was owed me, but effected nothing and wasted all that time . . ." (letter to Fattucci, December 1523. Ramsden no. 157). But then, Michelangelo addresses Julius, "my time does not disturb you or distress" (Gilbert no. 6, l. 7); you do not respond to my demands: "Not echo's voice . . . [is] fitted to our want" (loc. cit., l. 10); if you are not unwilling, you must be incapable: "The Heavens . . . give us a dry tree to pluck our fruit" (loc. cit., l. 14), evoking an old woman's withered breast (chapter 1). By cutting off money for stones you petrify me. Julius' death in 1513 removed his outer

power over Michelangelo, and the frequently hostile relations of his heirs with Michelangelo's subsequent papal patrons limited theirs. Thus the external conditions for withholding by Michelangelo came into being. For a few years he returned to work on the tomb. Then it *"lost its importance . . .* for the artist. . . . From . . . 1517 onward Michelangelo worked on the Tomb only at times when he had no other important work in hand" (Wilde 1978, 106); and while from 1513 to 1542 he repeatedly obliged himself in contracts with the heirs to undertake no other important work before finishing the Tomb, he also recurrently did much to promote and little to resist the intrusion of such work. Two years after Julius' death Michelangelo began "dreaming and scheming for . . . the façade [of San Lorenzo]" (Hartt 1970, 124). When "in 1516 Leo X . . . decided that San Lorenzo . . . needed a marble façade . . . a number of Florentine architects were asked to submit designs, but there is no indication that Michelangelo, not an architect and preoccupied with the Tomb, was considered eligible. . . . It appears that the artist himself offered to design and execute the façade" (Steinberg 1975a, 11).

For "only a papal commission could extricate him . . . from his obligation to Julius' heirs" (ibid.); allow him to *act* as if it did not exist—once the heirs did not themselves release him (as the Opera del Duomo in Florence had done with regard to the twelve statues of Apostles) or at least did not press their claim (as the heirs of Pius III did not).

A papal commission could, however, probably assuage Michelangelo's *guilt* about withholding work from the now dead sustainer of his life only on several conditions.

First, that Michelangelo's actions did not themselves contribute to the subsequent Popes' requests. But his initiatives repeatedly did just that. Michelangelo habitually denied their existence to others and probably also to himself; he is unlikely to have succeeded in either regard.

Second, Michelangelo had genuinely to attribute to the Pope the moral power of releasing him from contract, yet, in my surmise, hard as he tried, he could not convince himself that the Pope's capacity extended as far as he needed it to go. He did, to be sure, declare that "those [Julius' heirs] who choose to be cross

must be cross. *It is enough for me* that I have acted in such a way that the Pope can't complain about me" (letter to Luigi del Riccio, November 1542. Ramsden no. 229). But while at one point, for instance, "the Pope . . . certified in a *motu proprio* (November 17, 1536) that the artist could not fulfill his obligation with the heirs 'by virtue of just and legitimate impediments' . . . declared him free of any guilt, ordering him to work exclusively on *The Last Judgment* until its termination," "his conscience was still not free concerning the Duke of Urbino. . . . He conceded to execute two small works for him: a bronze horse and a salt cellar" (Tolnay 1954, 64). When the same "Paul III was made Pope," Michelangelo is apt to have told Condivi, he sent for Michelangelo and requested that he enter his service. Michelangelo answered that he . . . was bound under contract to the duke of Urbino. . . . The Pope . . . said: '. . . Where is this contract? I want to tear it up' . . . [So far from being content—] Michelangelo was on the point of . . . going . . . to Genovese country [beyond the Pope's reach—] . . . to finish his work [for the Heirs] there . . ." (Condivi, 75).

Third, as an alternative or a supplement to the factor just mentioned, Michelangelo had to predict that the Pope would react devastatingly to Michelangelo's refusing a commission proposed by him. While Michelangelo asserted that much, as if it could be taken for granted, he was probably unable to convince himself on this score either; for his sense of himself as one "forced" (chapter 7) was accompanied by words and acts proclaiming the opposite. It should have been particularly difficult for Michelangelo to see himself fully as a prisoner *(prigione)* with regard to commands which coincided, and not even by chance, with his wishes; to convince himself that "I was contending, as far as I was able, against the demands of Pope Leo and Clement" (letter to an unnamed Monsignore, October/November 1942. Ramsden no. 227).

Obscurely Michelangelo is apt to have sensed a sameness between himself and "the men of Pietra Santa who undertook to quarry a specific amount of marble some six months ago: they will neither do the quarrying nor return . . . the hundred ducats I gave them. . . . They have taken a bold course" (letter to Berto da Filicaia, August 1518, Ramsden no. 129).

Thus Michelangelo, exposed from within and without to the charge of deceit, may take the bold course of denying deceit at the expense of the heirs and claiming it as committed on their behalf, not seeing that he is undercutting his concurrent insistence on his honesty. "While pretending," he will have told Condivi, "to be at work, as he partly was, on the cartoon [for The Last Judgment] he worked in secret on the statues that were to go on the tomb" (Condivi, 75). This for Clement; as to Paul, "he was hoping to satisfy the Pope with gentle words" (loc. cit., 77).

*Attempting to get rid of the knowledge that the chief cause of the "tragedy" was his own desire to withhold from Julius, Michelangelo attributed this motive to the Medici Popes:* "Pope Leo who did not wish me to execute this Tomb, pretended that he wanted the façade of San Lorenzo . . . built" (letter to an unnamed Monsignore, October/November, 1542. Ramsden no. 227): "the façade of San Lorenzo and later the Library and the New Sacristy regarded as mere pretexts to prevent the completion of the Tomb of Julius!" (Weinberger 1967, 190). The magnitude of this delayed distortion may be commensurate with the unending intensity of both the urge and the guilt from which it arose. Earlier Michelangelo had merely denied his own wish to harm the dead Pope without attributing it to the living one: asking the future second Medici Pope to "release me from this affair in Rome," Michelangelo insisted, *it is not* that I do not wish to execute the said Tomb . . . that I ask to be released, but in order to serve him" (letter to Fattucci, April 1523. Ramsden no. 152).

That in fact *it is* may have contributed—by talion—to the noncompletion of a project (the façade), which had come into existence so as to allow inflicting that fate on another (the tomb): "Probably due to the new project for the Medici Chapel, *proposed* [by Michelangelo] in June 1519 and . . . commenced on November 4 of that year, work on the façade was called off. Suddenly, in March 1520, . . . the contract for the façade was annulled . . ." (Hartt 1968, 32).

With regard to the Tomb, Michelangelo withheld not only work, but also the repayment of advances. Here again, he attempted to exculpate himself: "according to his own account, it

[the money received from Pope Julius] had all been spent on marble and on living expenses, and he was . . . out-of-pocket" (Hartt 1968, 266). "I maintain," he writes late in the affair, "that the heirs of Pope Julius owe me five thousand scudi" (letter to an unknown Monsignore, October/November 1542. Ramsden no. 227)—"I maintain" that even "with a clear conscience." Probably not: throughout the four decades during which Michelangelo attempted to justify his conduct—the theme "so far from I owing them, they owe me" appears and disappears, with or without a figure, and in the former case with one that varies; and so it goes with the theme "I am willing to reimburse" replacing, with similar prominence and intermittence, the theme "rather than reimbursing I should be reimbursed."

That the Tomb was a "tragedy" for Michelangelo may mean his distress about being prevented from executing a project as vast as he preferred it. That distress appears to me to have been minor, at least after 1515 when he was himself eager to impede. Or the "tragedy" may have consisted in Michelangelo's distress about his conflict with Julius' heirs through three decades. That distress was, in fact, substantial. The most powerful factor making for it was, it seems to me, *his wish to harm the dead Julius, arousing guilt and fear; which in turn lent strength to several painful reactions.*

Perhaps, Michelangelo may have sensed, I fail to complete not because they prevent me nor because I don't want to, but rather because I am unable to (see chapter 5)—a suspicion all the more plausible as his distress about the affair did at times reduce his capacity for work. Such a suspicion led Michelangelo to accent (and probably to exaggerate) the extent to which others entertained it, and to suffer on that account.

Similarly, Michelangelo's guilt about what he was (not) doing—not working on the Tomb nor reimbursing the heirs—made him, to the very extent to which he was warding off this guilt, accent the acceptance by others (the heirs in the first place) of the charges in question, and suffer from the resulting belief in a world thinking ill of him, *precisely in ways in which he was disposed to think ill of himself.* "Rumors . . . that he had . . . invested 'at

usury' . . . the money received from Pope Julius and had produced nothing" (Hartt 1968, 266) seem to have been the occasion for protracted anguish in Michelangelo.

He had always tended to believe that others were "speaking ill of him," inventing or accepting calumnies. "Giovan Simone," he writes to a brother, "when speaking about you and Gismondo [another brother—] in front of Ser Giovan Francesco [Fattucci] the other morning I said . . . that you had never done anything but speak ill of [me] all over Florence" (Summer of 1531. Ramsden no. 185). "You have believed," Michelangelo declares in a poem probably addressed to Julius II, "what's fabulous and false" (Gilbert no. 6, l. 3). "Febo," Michelangelo writes to a young man in whom he was much interested, "you have conceived for me a great hatred . . . owing to what other people say . . . having made trial of me . . ." (September 1534. Ramsden no. 198). Even one's best friends may make the worst of ambiguous words: "and I do this," Michelangelo is reported to have said, explaining to intimates why he had been so explicit on a delicate point, "so that you do not give some malign interpretations to my words" (Giannotti, 93).

Any publicly audible charge may be sensed by Michelangelo as a condemnation to death: "I perceive from your letter that Bernardo Niccolini has written and told you that I was indignant with him about a report of yours which said that the Lord of Carrara was making numerous *charges* against me and that the Cardinal [Aginensis] was *complaining* about me. . . . He read it to me in a haberdasher's shop in public, as if it were a *formal indictment,* so that thereby everyone knew that I was *condemned to death* . . ." (letter to Buoninsegni, January 1519. Ramsden no. 137).

What makes unfavorable beliefs about me so distressing, Michelangelo of course asserts, is their very distance from what I really am: "to have to defend myself against the rogues I sometimes . . . go out of my mind. I am not a thieving usurer but a Florentine citizen of noble family, the son of an honest man and not from Cagli" (letter to an unknown Monsignore, October/November 1542. Ramsden no. 227).

It is not I who attribute my unfavorable beliefs about myself to others, it is they who attribute their bad qualities to me! The

56

spokesman of Julius' heirs "has fashioned a Michelangelo . . . made of the same stuff as himself" (ibid.). "How will . . . [my] chaste wish [toward Tommaso Cavalieri] . . . ever be heard by those who . . . see themselves in others?" (Gilbert no. 56, ll. 9–11). "The mob . . . may charge to others its own taste" (Gilbert no. 81, ll. 5–6).

In the affair of the Tomb it becomes Michelangelo's foremost demand that the unfavorable assertions about his conduct cease.

Those whom he is said to have damaged, the heirs, could make such allegations cease by declaring themselves satisfied with as little as Michelangelo would want to furnish. Awaiting with anguish the ratification by the Duke of Urbino of the last contract on the Tomb, Michelangelo sends Luigi del Riccio two madrigals in which he as lover speaks to his beloved, and adds: "Love has ratified the contract I made between him and myself; but as to the other ratification . . . I don't know anyone who thinks me *worthy* of it" (September 1542. Ramsden no. 224). The heirs became like his father and his brother: "in place of the gratitude that was his due, what he received . . . was odium . . ." (Condivi, 83).

Or the Pope could reduce the slanderers to silence: "I'll always go on working for Pope Clement . . .—with this proviso, that the taunts to which I see I am being subjected cease, because they very much upset me and have prevented me from doing the work I want to do for several months now" (letter to Fattucci, October 24, 1524. Ramsden no. 174). It is Condivi's aim, probably set by Michelangelo, "to extirpate . . . [the] opinion . . . that he [Michelangelo] had received sixteen thousand scudi and was not willing to fulfill his obligation" (79).

If only those voices out there would stop! Only then might I be able to silence the voice within which concurs with them: "the ill will the relatives of Julius bear me—and not without reason . . ." (letter to Fattucci, November 1, 1526. Ramsden no. 178).

It may be that voice of my own which renders me susceptible to the voices outside and thus makes me require their cessation which it is beyond my power to produce: "according to [the heirs] . . . I have . . . *robbed* the sanctuary. They are making a great outcry. . . . I ought to be able to find a way of putting them to

silence, but I'm no good at it" (letter to an unknown Monsignore, October/November 1542. Ramsden no. 227).

For withholding both his creations and the repayment of advances for them is robbing; and *probably Michelangelo has obscurely preserved urges of early life to seize what was then withheld from him and thus to rob those who withheld, injuring them in that act, even killing them.*

It is *probably both Michelangelo's fear of talion for his urge to rob and guilt about it as well as his sense of resourcelessness (chapter 3) which make him expect that he will perish from the reimbursements and indemnities on which the heirs are insisting and which he could probably afford:* "they are demanding such damages that a hundred such as I would not suffice to discharge them. . . . I should be unable to exist in this world . . ." (letter to Fattucci, November 1, 1526. Ramsden no. 178).

"I desire to be rid of this obligation," Michelangelo habitually declared about the Tomb, "more than to live" and "[I am] chained to this Tomb" (letter to an unknown Monsignore, October/ November 1542. Ramsden no. 227). The chains were probably as physically unconstraining as those which he put around some of his figures (see chapter 7): his desires and his own reactions to them appear as constraints from without.

In rare and brief moments, in circumstances yet undiscovered, Michelangelo's obscure determination to rob and to suffer for it weakened. He then suddenly discovered that there were ways out at moderate cost: "I don't want to go to law. They [the heirs] can't go to law if I admit that I am in the wrong. I will assume that I have been to law and have lost and must pay up. This I am prepared to do. . . . His Holiness our Lord can assist me . . . also in this that I may have to return as little as possible by having some of my arguments taken into consideration . . . such as the time I wasted without remuneration when the Pope [Julius] was at Bologna and on other occasions. . . . As soon as I'm clear as to how much I have to return, I will review my resources. I'll . . . so arrange things that I'll make restitution and . . . get on with . . . work . . ." (letter to Spina, April 19, 1525. Ramsden no. 168). Years later, "concerning the Tomb of Julius . . . I've thought it over several times as you told me to, and it

seems to me that there are two ways of freeing oneself from the obligation. One is to do it; the other is to give them the money to have it done themselves. Of these two courses, only the one agreeable to the Pope can be taken. To do it myself will not . . . be agreeable to the Pope, because I should not be able to devote myself to his things. Therefore they will have to be persuaded—I mean whoever is acting for Julius—to take the money and get it done themselves. I would supply the drawings and models . . . together with the marbles that have been done for it. With the addition of two thousand ducats . . . a very fine tomb could be produced. . . . I could put down a thousand gold ducats now and the other thousand somehow or other later on . . ." (letter to Sebastiano, November 25, 1531. Ramsden no. 186). *Clear enough and feasible enough if only Michelangelo really wanted to "free" himself from the flagrantly painful and obscurely pleasurable state of violating an "obligation" toward a hated and loved father: as long as Michelangelo remains "chained" to that tomb, father to be buried in it is still with him.*

Examining Michelangelo's withholding—that is, robbing—we have perceived anew his belief in being robbed (see above). "Everything I have will be seized . . ." (letter to Fattucci, July 1524. Ramsden no. 164). The contract of 1532 between the heirs and himself, Michelangelo came to hold, "did not indicate that it was read over in Pope Clement's presence. . . . And this was because, when Clement had sent me to Florence that same day, Gianmaria of Modena, the Ambassador [of the Duke of Urbino] got together with a notary and made him extend its scope to suit himself, so that when I returned and had access to it, I found included in the contract . . . the house in which I was living. . . . [I was made to go to Florence that day] in order that I might be gotten to go away and that they on the strength of the contract might rush in and take possession" (letter to an unknown Monsignore, October/November 1542. Ramsden no. 227). Replacing fear for himself by humor about an other (and revealing the robbing behind the being robbed) Michelangelo was fond of telling the story of the painter who composed his works solely of ele-

ments taken from others. When the owners recovered their properties at The Last Judgment, he was miserably denuded. "If . . . the owners of those ornaments with which you have clothed me come to get them," Michelangelo tells his interlocutors at the conversation recorded by Giannotti, "I shall remain naked" (Giannotti, 43): once more nakedness is *probably evil, incapacity and ugliness rather than reflection of the divine, strength and beauty as in so many of Michelangelo's nude figures.*

The other, we have already learned, intends to rob me so as to make me die from lack of resources—or of self: "Just about here my love . . . took my heart, but further on my life; with beautiful eyes he promised me relief, and with the same he wished to dispossess (tor) me" (Gilbert no. 34, ll. 1–4). By the very love they are inducing "parents, friends, masters" intend to make man "dispersed and dissipated," to "rob (rubare) man from himself" (Giannotti, 69).

Instead of robbing with the sequel of death, one may kill for the sake of robbing. "If my existence is a cause of annoyance to you," Michelangelo writes his father on one of the rare occasions when he abandons a filial stance, "you have found the way to remedy this and you will inherit the key to that treasure which you say I have . . ." (June 1523. Ramsden no. 154).

Combatting his fear of being robbed, Michelangelo—apparently free for the moment from his customary forecast that the robbed one perishes—invokes his fear of death: the *only* event to be dreaded. He then insists on the lack of importance of possessions in comparison with life (he who attached his fortune to his body, when fleeing his city, in order to save that fortune from being requisitioned by the government of which he was a member). "I learned from your last letter," he writes his father who is worried about money, "how the matter is going. . . . Don't alarm yourself and don't be in the least depressed about it because to lose one's possessions is not to lose one's life. . . . Make the most of life and let your possessions go rather than fret about them; . . . I would rather have you alive, though poor, than you dead and all the gold in the world" (September 15, 1509. Ramsden no. 50)—*probably disclosing precisely a desire to "have you dead," which, in turn, contributes to Michelangelo's fear of his own death

60

as well as to his effort to prevent his father from becoming poor (see above).*

Let what I fear come and thus remove the fear! "I haven't a quattrino. However, I can't be robbed" (letter to his father, June 1509. Ramsden no. 46).

Foil the robbers by hiding. "When you take the money [sent by Michelangelo] to the Spedalingo [chief of a hospital serving as a bank], take Buonarroto with you, and . . . do not either of you mention it to a soul. That is to say, neither you nor Buonarroto are to talk about my sending money, either on this occasion or on any other" (letter to his father, September 15, 1509. Ramsden no. 50). "I am in need of money, so as soon as you get this, arrange with the Spedalingo to have it transferred to me. . . . Do not go talking about it, because I want it to be transferred to me here without anyone's knowing" (letter to Buonarroto, June 16, 1515. Ramsden no. 97). "You have the wherewithal to live . . . don't talk much about it for fear of its being stolen" (letter to his nephew, July 4, 1545. Ramsden no. 256). "I want you to have it moved into the house," Michelangelo writes to his father about The Bruges Madonna, "and not to let anyone see it" (January 31, 1506. Ramsden no. 6).

Michelangelo's penchant for hiding goes beyond valuables. "Lionardo . . . as regards your taking a wife, I had information this morning about several marriageable girls. I believe it was a broker who wrote . . . I'm sending you the said list enclosed with this. . . . Don't let anyone know that I've sent you the said list" (January 25, 1549. Ramsden no. 317). "I learned from your last," he wrote his father, "that it is said in Florence I am dead. . . . Let them say what they like and do not mention me to anyone, because there are some malicious people about" (June 1509. Ramsden no. 46).

Foil the robbers by fleeing. "In order to protect his by now considerable fortune from requisition by the government of the Republic to aid in the financing of its defense, Michelangelo . . . fled Florence in September 1529 . . ." (Hartt 1968, 32).

Michelangelo's fight against robbing goes beyond concern for himself. "I should not leave here," Michelangelo justifies his refusal to return from Rome to Florence "until I brought the fabric

61

of St. Peter's to a stage at which my design could not be . . . altered nor an occasion given to thieves and robbers to return there to thieve and rob as they are wont and as they are waiting to do" (letter to his nephew, July 1, 1557. Ramsden no. 436). "If I were to abandon the . . . fabric [of St. Peter's] . . . it would gratify sundry thieves and robbers . . ." (letter to Vasari, May 22, 1557. Ramsden no. 434). That Michelangelo is not one of them is insured not only by his fighting them, but also by his refusal of any salary for the post he is thus using.

Yet when, in a sarcastic vein, Michelangelo imputes unfavorable beliefs about himself to his father, what comes to his imagination? "All Florence knows the . . . rich man you were and how I've always robbed you . . ." (June 1523. Ramsden no. 154). *The decades of bestowing benefits on his father probably find their reward here: instead of robbing those who have withheld from him, and thereby incurring fear and guilt, he can be indignant against them for charging him (in his imagination) with having done so:* his contrary conduct renders that terrible charge absurd.

*It is terrible probably because of Michelangelo's obscure sense of wanting to rob, which he can express only in an unserious vein, imagining a world in which robbing would entail neither fear nor guilt.* "I opened negotiations for the purchase of a plot of land near Santa Caterina from the Chapter of Santa Maria del Fiore in order to build . . . [a place suitable for working]," Michelangelo informs the future Clement VII. "They made me pay sixty ducats more for it than it's worth . . . saying they cannot contravene the terms of the Bull of sale they had from the Pope. Now if the Pope is issuing Bulls granting license to rob, I beg Your Most Reverent Lordship to get one issued to me, too, because I have more need of it than they . . ." (July 15, 1518. Ramsden no. 125); for I only rob what they should have bestowed on me.

# CHAPTER 5

# DIVINE AND DEFECTIVE

*A S WE WOULD EXPECT in one who may have felt abandoned by his early persons and who was intent on deflecting his anger from others (see chapter 6), Michelangelo was beset by a sense of worthlessness which he expressed more clearly with advancing age.*

Michelangelo was apt to perceive (often correctly) all manners and amounts of evil urges and deeds in others. "I'm sorry," he will write to his preferred brother, "you behaved so lousily (*pidocchiosamente*) to Filippo Strozzi over such a *small* thing . . ." (April 20, 1507. Ramsden no. 21). "It has," he advances perhaps with humor about Antonio da Sangallo's plan for St. Peter, "so many dark lurking places . . . that they afford ample opportunity for innumerable rascalities, such as the hiding of exiles, the coin-

63

ing of base money, the raping of nuns and other rascalities . . ." (letter to Ferratini, January 1547. Ramsden no. 274).

The others whom Michelangelo judges evil pass that judgment on him. "Dearest father . . . you have . . . made trial of me (voi m'avete sperimentato), you and your sons, these thirty years . . ." (September/October 1521. Ramsden no. 149). "Workmen . . . speak ill of me . . ." (letter to Gondi, January 26, 1524. Ramsden no. 161).

Yet this is merely "because they find me . . . strange (bizarria) and obsessed (pazzia)" though this "harms no one but myself" (ibid.). Michelangelo was, as far as we know, unwilling to admit having committed any particular sin. "I want to confess a wrongdoing to your Lordship [an unknown Monsignore—]" is a most unusual statement to be made by Michelangelo. Our bewilderment soon ceases when we learn that the misdeed was noble enough and in addition serves to refute other charges raised against him: "while I was at Carrara [around 1515], when I stayed there thirteen months for the . . . Tomb, being in need of money, I spent a thousand scudi on marbles for the said work which Pope Leo had sent me for the façade of San Lorenzo, or rather to keep me occupied, and I made him excuses. . . . This I did for the love I bore the said work, for which I am repaid by being called a thief and a usurer . . ." (letter to an unknown Monsignore, October/November 1542. Ramsden no. 227). Michelangelo's usual stance is rather that which he adopts when two assistants leave him in Bologna in 1506 and tell his father why: "Dearest Father— I have today received a letter of yours from which I learned that you have been told a long story by Lapo and Lodovico. . . . But . . . I have done no wrong in this matter about which you reprove me, either to them or to anyone else, unless it be that I did more for them than I need have done; and all those with whom I ever had dealings know very well what I pay them. . . . Lapo and Lodovico know it better than others . . ." (February 8, 1506. Ramsden no. 13). Michelangelo is apt to spend much effort in denying unfavorable allegations about him which he perceives as all too readily invented and accepted (see chapter 4). He will pretend consenting to a specific charge—indeed, to any and all particular charges—only as an expression of the depth of the global

64

charge he chooses to raise against himself, that of his *essential* badness. Thus, at the occasion just presented, he also affirms to his father that "I value your reproof since I deserve to be reproved as *a miserable sinner*" (ibid.). "When I hear that you are complaining about me and saying that I've turned you out," Michelangelo writes to his father many years later, "I'm . . . amazed. . . . I am certain that never to this day, since the day I was born, has it ever occurred to me to do anything, either great or small, opposed to your interests; and all the toils and troubles I've continually endured I've endured for your sake. . . . However, be it as it may, I will try to imagine that I've always brought shame and trouble upon you and thus, as if I had done so, I ask your forgiveness. Imagine that you are forgiving a son of yours who . . . *has done you every possible wrong on earth*. And thus again, I beg you to forgive me, like *the reprobate (tristo)* I am . . ." (September/October 1521. Ramsden no. 149). I am "filled with sin" (Gilbert no. 291, l. 1). "Some sin, to me a secret, is driving my spirit to great grief" (Gilbert no. 289, ll. 1–2).

Late in life, Michelangelo seems to have attributed to himself, beyond the essential quality of a *tristo*, particular deeds about which he felt guilty. But they were not ordinary acts like that of not fulfilling his obligations toward the heirs of Julius II. Rather, what he came to feel himself to have done was deicide. First this was a metaphor: "On the strength of [the contract concerning the Tomb of Julius] . . . I am stoned every day as if I had crucified Christ" (letter to an unknown Monsignore, October/November 1542. Ramsden no. 227). Then Michelangelo apparently came to sense this charge as real: in his late drawings of the Crucifixion he seems to present beneath the Cross St. John as crushed by guilt about what he has done by his sinning. Michelangelo may also have come to see himself as having attacked St. Peter: "in . . . his youth he had dreamt of seeing his masterwork [the Tomb] rise three stories high under the vault of a new choir, overlooking St. Peter's Tomb and giving the church a spatial climax that would have prolonged and commanded its longitudinal access [at the expense of centrality, that is, of the Church as a martyrium for Peter]. . . . 'Once I had hoped to raise me by thy height' he had written in a sonnet to Julius II. . . . He had meant to use

St. Peter's as . . . [a] frame for his art [reducing the importance of the Tomb of St. Peter]. Now . . . he . . . diverts the subject of the second Pauline fresco from Christ's charge to St. Peter to . . . [St. Peter's] crucifixion. . . . This change of subject must have come about at Michelangelo's prompting" (Steinberg 1975a, 44). And in that fresco Michelangelo may have conferred his own features upon a Roman looking at the execution with disquiet while a Christian accuses him by pointing a finger (op. cit., 55).

The worthlessness which Michelangelo declares is not only being evil—on the Sistine Ceiling, possibly, "the decapitated head of Holophernes . . . is a self-portrait . . ." (Tolnay 1955, 180) and surely the flayed skin of Saint Bartholomew's face in The Last Judgment—but also being incapable. "Indeed, indeed of nothing I am made" (Gilbert no. 312, l. 3), "I, crippled [zoppo] and naked" (Girardi no. 175, l. 8): a feeling which I have already *conjectured to be that of an infant prematurely separated from its mother (chapter 2), as well as that of a small child with inadequate and unreliable caretakers (chapter 3).*

To be sure, helped by his own recognition of his achievements and that which was bestowed on them, Michelangelo opposed a sense of supreme capacity to that of defect.

Then one way of not only expressing his sense of incapacity but also of ridiculing it and of declaring his supremacy was to speak slightingly of himself. Thus Michelangelo, exaggerating upon formulas of politeness, may assert himself vastly inferior to an other though this contention sharply deviates from agreed public estimates. "I beg your Most Reverent Lordship," he writes to Cardinal Bibbiena, "not as a friend nor as a servant, for I am unworthy to be either the one or the other—but as a man of no account (vile), poor and foolish [matto] to obtain for Bastiano Veneziano . . . some share in the work at the Palace now that Raphael is dead. But should your Lordship think that a favor would be thrown away on a man like me, I think that one might still find some pleasure in granting favors to fools, just as one does in onions as a change of diet when one is surfeited with capons. You are always granting favors to men of esteem; I beg your Lordship

66

to try out the change with me" (May/June 1520. Ramsden no.
154). Such words, the intended beneficiary reports to their au-
thor, "make everybody laugh" (quoted by Symonds 1893, v. 1, p.
355). Perhaps Michelangelo would not have chosen them if they
did not, by themselves and by this intended effect serve to both
express and combat a sense of defect.

Similarly, the discrepancy between the comparative worth of
himself and an other alleged by Michelangelo and that generally
accepted may be such as to suggest the opposite of what he de-
clares. Thus when Michelangelo presents "the disparities be-
tween us" to Cavalieri: "he who is unique in all things can have
no companions in any. Your Lordship . . . [is] matchless and un-
equaled—light of our century, paragon of the world" (January 1,
1533. Ramsden Draft no. 4). Yet Michelangelo, in love, may not
have been wholly insincere; his state probably reinforced his sense
of defect and rendered it more pleasurable.

In any case, Michelangelo allows only himself to affirm his
imperfection; exaggerating the degree to which others dare do the
same or even imagining that they do it, he reacts violently as the
story of his encounter with Leonardo in the piazza SSa Trinità
illustrates. "Sebastiano del Piombo advised Paul III that Michel-
angelo ought to paint The Last Judgment in oil. Michelangelo
considered this an insult [implying that he was a woman or lazy]
which he could never forgive" (Tolnay 1948, 22).

Once the others' belief in my incapacity has been proved fla-
grantly wrong, it can be relished as underlining the opposite.
Having completed the bronze statue of Julius II for S. Petronio,
Michelangelo recalls with relish that "the whole of Bologna was
of the opinion that I should never finish it" (letter to Buonarroto,
November 10, 1507. Ramsden no. 37).

*Their* incapacity is stressed by Michelangelo: "I have lost a
month of my time on the said work, owing to their [never mind
who—NL] bestial ineptitude (*ignoranza e bestialità*) . . ." (letter to
Luigi del Riccio, May 1542. Ramsden no. 214).

*Their* incapacity is not only something that occurs against my
will and to my detriment: I may arrange for its display and enjoy
it. "He liked to be amused and would keep company with almost
anyone who could . . . make him laugh. . . . Michelangelo was

. . . vastly entertained by the doings of Topolino who . . . 'imagined himself to be a good sculptor though he was a very poor one' [Vasari]. But this did not prevent [sic] Michelangelo from taking an interest in his work though he sometimes nearly died of laughter in the process. Similarly he liked the society of Domenico Menighella, a poor painter, but an . . . amusing man who sometimes came to Michelangelo for drawings. Whereupon 'Michelangelo who scarcely could be persuaded to work for kings would put aside everything to make simple designs . . .' These drawings Menighella used to copy and would then go about the country selling them to the peasants. Afterwards he used to cause Michelangelo endless amusement by telling him of his adventures and how he once added a splendid cape to a figure of St. Francis to please a patron. . . . On . . . [one] occasion Bugiardini [another such intimate] did a *Night* based on Michelangelo's figure in the New Sacristy, but not being satisfied with the owl added a 'lantern, a candle, a nightcap, pillows and bats and other things suggestive of darkness' which caused Michelangelo almost to choke with laughter when he saw it" (Ramsden 1963, v. 1, XLIV–XLV).

When Michelangelo insisted that his marble sculptures existed in their blocks before he carved them, he *may have fought against the belief that he had created them *ex nihilo,* being indeed *divino.** This belief was welcome as it in turn *probably opposed that of being defective.* But it *may also have made Michelangelo anxious and guilty as an expression of *superbia* such as that of Phaëthon punished by Zeus, or that of the First Parents punished by God.* Hence when a man asks Michelangelo for a portrait of his beloved, Michelangelo insists that "her . . . beauty has been made by God. . . . *Not I,* he only, could create" (Gilbert no. 176, ll. 12–14). In fact, all "painting . . . is merely to copy . . . one single thing of those made by God. . . . That painting is . . . divine which . . . best copies any work of . . . God" (Hollanda, 69).

In the "single thing of those made by God" which Michelangelo mostly "copied," the male body, he stressed the opposite of the defectiveness he probably attributed to his own body. In my surmise, his perception of himself in his seventies only rendered extreme a sense which had always been with him: "I am

68

broken up, ruptured and cracked and split" (Gilbert no. 265, l. 22), my body is "inside a leather sack some strings and bones" (loc. cit., l. 35).

In contrast, "the evolution of Michelangelo's figure style [was] towards the expression of the capabilities . . . of the human body . . ." (Hartt 1970, 39). "His . . . vision [was one] of human beings of more than natural power . . ." (Hartt 1968, 17). Right at his beginning Michelangelo denies the weakness of the child (see chapter 3): in The Virgin of the Stairs "the child is an . . . invention by Michelangelo. . . . He is a . . .'hero' . . . rather than the usual infant. His muscular form . . . shows great . . . power" (Tolnay 1947, 76); "the back and right arm of the Christ Child are . . . already surpassing the greatest sculpture of the early Renaissance in . . . muscular power" (Hartt 1974, 413). The Sistine *ignudi* are "glorying in their . . . prowess" (Hartt 1964, 126). Up to the time of the Pietà in Florence Christ is apt to have a powerful body, even on the Cross (the drawing for Vittoria Colonna) which he carries himself (S. Maria sopra Minerva). He may overcome gravity (the drawings of the Resurrection and even the Pietà in Milan).

What is conspicuously absent may be covertly present: in the Medici Chapel, "in contrast to the . . . power of the side of the statues exposed to the spectator, the concealed views suggest foetal positions . . ." (Hartt 1968, 188).

Yet what dominates in Michelangelo's work is the contention that a David's power *colla fronda* (with the sling) is, according to the words on the drawing of the bronze David, also that of *io coll'arco* (with the chisel).

*Probably in order to disprove incapacity, Michelangelo proclaimed his power by the very amount and speed of work which he accomplished or merely promised.* "In a day he lives a century who in that time learns everything . . ." (Gilbert no. 193, ll. 3–4.) *Failing to live up to his sometimes unfeasible promises he confirmed what he attempted to deny.*

For Michelangelo the fact of owing anything in his work to others *probably meant proving his incapacity.* Hence his aversion against incurring or acknowledging any debt to teachers, previous or contemporary masters, and assistants (see Barocchi

69

1962, notes 329 and 342). "They had given everyone to understand," thus he explains his dismissing two assistants in Bologna, "that they were the ones doing this work or at least jointly with me . . ." (letter to his father, February 8, 1506. Ramsden no. 13): if I don't do all of it, I may be doing none of it (chapter 3).

Once more, the extreme to which Michelangelo went to disprove a negative quality resulted in displaying it. "The work [for the facade of S. Lorenzo] reached immense dimensions under Michelangelo's hand, and yet he wanted to direct all its aspects singlehanded, so that little progress was made and . . . failure was inevitable" (Wilde 1978, 115).

Michelangelo strove to raise others' estimate of his capacity beyond what he himself knew it to be: "a work of painting . . . should seem to have been done . . . with no labor at all, although in fact it was not so. . . . It should seem done very easily, although it has cost hard work" (Hollanda, 72–73).

Hence (in part) Michelangelo's aversion against his products being seen while he was producing them; hence his inclination to destroy imperfect preparatory products, such as drawings.

Yet the urge to display rather than disprove incapacity won out in the conspicuous incidence of the nonfinito.

When in the 1530s all in man that is not oriented toward God became for Michelangelo associated with evil (chapter 8), he ceased to insist on the capacities of the body. The powerful crucified in the Pietà for Vittoria Colonna (fig. 9) is followed by the emaciated Christ in The Milan Pietà (fig. 31). In The Conversion of St. Paul "arms shrink. . . . Only Christ's right arm is vast. . . . Everywhere else men's arms are hidden or minimized—incapacitated either by cleaving too close to the body or by some . . . malfunctioning gesture, such as letting a truncheon slip through splayed fingers" (Steinberg 1975a, 21). Petrarch's "tall column" (recalled by the young Michelangelo on the drawing of the bronze David in which he attributes that hero's power also to himself) is now "broken."

Not only evil, but also incapable; not only evil and incapable, but also ugly. "I'll pray," Michelangelo addresses the "Lady" of

70

his poetry, "that [my external body] . . . you'll want with you
. . . in heaven"—"though [it is] ugly" (Gilbert no. 119, ll. 4–17).
"Lady, while you are swerving your beautiful eyes near me, in
them myself I see, just as yourself in mine you are observing.
. . . In fair eyes I see myself so ugly, and you in mine, ugly, see
yourself so fair" (Gilbert no. 253, ll. 1–10). In his seventies "my
face . . . causes fright" (Gilbert no. 265, l. 40), "my clothes would
scare crows" (loc. cit., ll. 41–42).

*Perhaps Michelangelo obscurely felt that he was annulling
his own ugliness by excluding—before the 1530s—the ugly from
his creations.*

Then only man was beautiful. He had "an aversion to animal
appendages [of the human body] . . . classical or christian . . ."
(Hartt 1968, 63). Only The Angel in Bologna has wings. In The
Battle of the Lapiths and Centaurs, "with his . . . abhorrence of
the monstrous . . . Michelangelo has so subordinated the horse
parts of the Centaurs that they are difficult to make out . . ."
(Hartt 1974, 414).

And, of course, his vision . . . [was one] of human beings of
more than natural . . . beauty" (Hartt 1968, 17).

It is a beauty which its bearers properly value. The Sistine
*ignudi* are "glorying in their beauty . . ." (Hartt 1964, 126).

All this ceased in the 1530s, when Michelangelo, instead of
seeing in (male) beauty an epiphany, came to perceive it as a ve-
hicle of perdition (chapter 8).

Not only evil, incapable, ugly, but also disgusting; and wal-
lowing in that.

His house of decades in Rome contains—thus he begins its
description—"the spider and her thousand webs" (Gilbert no. 265,
l. 5); in fact, in his very body "a spider web is nestled in one ear"
(loc. cit., l. 43).

"With spitting breath I do not sleep, but snore" (loc. cit., l.
45): a perception of old age which, in the surmise I already ex-
pressed, is not likely to have been preceded by a clearly contrast-
ing one.

Michelangelo imagines surrounding himself—his house—with

excreta; rather, to be sure, others forcing them on him: "any who have a . . . stool or pot . . . won't ever come to change my sheets without" (loc. cit., ll. 13–15).

With Michelangelo everything is apt to be colossal: "There is the dung of giants at my doors; those who eat grapes or take some medicine go nowhere else to empty, in great numbers" (loc. cit., ll. 7–9)

Michelangelo attempted to reverse the verdict he was passing on himself not only by creating, but also by loving (chapter 2).

To love is for Michelangelo to transmute his own ghastly self into the glorious self of the beloved. "A sketch, when I was born, of no account . . . reborn from you . . . perfect" (Gilbert no. 234, ll. 9–11).

Now I am joined to him: "my wishes are within your will. . . . Within your heart are my ideas shaped. When you have taken breath, then I can speak" (Gilbert no. 87, ll. 9–11).

Now he is joined to me: "I with your . . . eyes see gentle light, while mine are so blind I never can; with your feet on my back can bear a burden, while mine are crippled. . . . Having no feathers, on your wings my flight, by your . . . wits . . . drawn towards heaven. . . ." (Gilbert no. 87, ll. 1–6). "I am dearer to myself than was my habit, more than myself since you have been in my heart, as a bare rock will get much less regard than a stone with its carving added to it . . . I go as one who bears arms or enchantment so that all dangers fall away from me, made safe in every place with such a seal. Against fire, against water I am potent, all blind men in your sign I make to see and with my spirit all poisoning I heal" (Gilbert no. 88, ll. 1–14).

Without merging with an other, one may change one's bad self into a good one by shedding one's skin, having one's badness concentrated in an outermost layer which can be removed by oneself (first) or by God (later) (chapter 2).

In Michelangelo's poems much skin is shed. The silkworm "its own hide unskins (la sua scorza spoglia)"; "the serpent sheds

its skin *(si discoglia)"* (Gilbert no. 92, ll. 3 and 7). "Time changes
. . . its pelt" (Gilbert no. 49, l. 26). "In Rome . . . [Christ's] skin
is being sold" (Gilbert no. 10, l. 7). "Men change skin" (Gilbert
no. 103, l. 11). So I, too, "change my skin" (Gilbert no. 159,
l. 7), acting on the metaphor: "He often slept . . . in . . . [his]
boots . . . and he has sometimes gone so long without taking
them off that then the skin came away like a snake's with the
boots" (Condivi, 106).

The flayed skin, that of St. Bartholomew (Michelangelo him-
self) in The Last Judgment, is, once more, the bad self—much
sexual pleasure is of the skin—the removal of which leaves me
with a good one: "Lord, in the final hour . . . take me *out of* me
. . ." (Gilbert no. 159, ll. 15–16), "oh strip me of myself" (Gilbert
no. 31, l. 15). As the silkworm "only in dying may be called well-
born," "only in death can my condition turn" (Gilbert no. 92, ll.
7–8) Michelangelo thus combats his fear of death; see chapter 6).
My skin is to my good self what the marble block's "husk" or
"surplus *(superchio)"* is to the sculpture already existing within:
"Sometimes . . . good actions . . . are hidden by . . . [the soul's]
. . . body surplus" (Gilbert no. 150, ll. 5–7). In the Pauline Chapel,
"as Paul's light-hued body falls free, his opaque outer garment
. . . drops from him . . . the shedding of an old skin in the
emergence of the convert to a new birth" (Steinberg 1975a, 39).

The bad self may even become an instrument in the creation
of the good self: in Bacchus the satyr " 'furtively enjoys,' as Con-
divi says, the grapes [of salvation] . . . enveloped in the flayed
skin. . . . The skin and head of the tortured animal emerge be-
tween his own goat feet. . . . He holds and supports [the flayed
skin] because in it is laid the fruit . . . which he smilingly touches
with his lips" (Wind 1968, 185) (fig. 27).

Can I myself put such fruit into such skin? Perhaps "the idea
of the deification of man by his own force . . . played . . . a
great role in the thoughts of Michelangelo during the execution
of the Sistine Ceiling" (Tolnay 1947, 18). In any case, from the
1530s on Michelangelo wards off such a feeling of power by in-
sisting on man's powerlessness (see chapter 7) with regard to his
own worth. "Above myself so high, Lady, *you make me* leap . . .
being no longer I. . . . Why do I not fly if *you will lend* your

wings. . . . *By your grace* I am cut off from my soul . . ." (Gilbert no. 152, ll. 1–12). The beloved man "invests *(assalire)* my soul with a love which *makes it* similar to his" (Girardi no. 105, l. 4). "Lord . . . *make me* one that pleases you" (Girardi no. 161, ll. 16–17). Here Michelangelo is the block which Cavalieri, Vittoria Colonna (whom he sensed as also masculine) and God are called upon to carve; no more the sculptor. "Just as [when] we put *(porre),* o Lady, . . . into the . . . stone a . . . figure," "you alone can pull . . . off *(levare)* my . . . surface," "the husk that is raw, hard and coarse": "in me there is for me no will or force" (Gilbert no. 150). The necessary condition for transmuting his worthless into a worthy self is to lay himself open to the impact of another male, to replace acting by being acted on, to accept lying beneath rather than standing above (see chapter 7).

## CHAPTER 6

# RAGING AND SUFFERING

W HEN THE PRIOR OF THE MONASTERY of S. Spirito offered the young Michelangelo corpses to *dissect*, he allowed him to do something "than which nothing could have given him greater pleasure" (Condivi, 17). But when it came to repay the Prior, Michelangelo's Crucifix presented a *minimally damaged* body, "without suffering," "graceful" (Hartt 1968, 58). Michelangelo "[avoids] carving . . . blood or . . . any sign of physical pain in his marble Pietàs" (Hartt 1975a, 24). In that of Rome "[wrinkles on the mother] appear no more than do tears or blood or the nails, the crown of thorns, the sponge, the lance, or any trace of the scourges. . . . The wounds in hands and feet and side . . . are shown . . . unobtrusively (op. cit., 29). The Christ Holding the Cross exhibits no suffering (Hartt 1968, 161). In the drawing of Tityos "[the vulture] seems to merge rather

than to penetrate. No wound is visible" (Hartt 1970, 250). Already in The Battle of the Centaurs and Lapiths "none of the horrifying details on which Ovid gloats for page after page is represented. . . . Ovid's audiences must have enjoyed the crushed skulls, gouged-out eyes, and spattered brains. . . . His whole life long, Michelangelo never represented such things. Here, not a weapon or missile connects with its intended victim, just as in the Sistine Ceiling David's sword does not touch Goliath, and in The Last Judgment not a single torment is depicted" (Hartt 1968, 48). There "Charon drives the damned from his boat with an oar as Dante says he should, but the oar never touches the bodies. The only torments shown are spiritual . . ." (Hartt 1974, 577–578), or fears of physical torments themselves not shown: *probably warding off an urge to impair others physically.* (Showing again and again unimpaired male bodies *probably also combats Michelangelo's sense of being defective; see chapter 5).*

Inflicting physical damage may come from anger, as Michelangelo hints during the period (circa 1500–1515) in which he was least beset by fear and guilt about what he might do to others and make others do to him (think of his encounter with Torrigiani who broke his nose). In the Sistine Ceiling "the genius below Daniel is . . . brutal. . . . Standing in full-face, with legs apart . . . he puffs his cheeks and shouts . . . in anger. . . . The genius below the Libyca . . . seems to be so furious as to attempt to hurl down the tablet. With his left arm across his breast and with his raised right arm he takes the position of the condemning Christ in the Last Judgment. . . . [As] the genius below Jeremiah . . . touches with both hands the corners of the tablet, it seems more probable that . . . [he] will take it down than hold it up" (Tolnay 1955, 68).

But in the mask Hartt no. 497 "the wildness of the expression . . . contrasts . . . with the fixity of the head": what Michelangelo—who with his terribilità "frightens everybody, even the Pope," in the words attributed to Leo X—strove for was the opposite of acting on anger: inhibiting it. In his Brutus "the expression of the face seems calm"; it is only "upon closer observation [that] one discovers . . . anger . . . controlled by . . . will" (Tolnay 1954,

76), an accomplishment that Michelangelo presents throughout the decades in S. Procolo, David, Moses, Christ as Judge (Tolnay 1947, 85; Sterba and Sterba 1978, 164); a counterpart in art to a "characteristic response" of Michelangelo in life, "[a] sour look and avoidance" (Hibbard 1978, 119). *His resolve of solitude may obscurely have been in part a device to protect himself against damaging from anger.* To prevent anger from completing itself in destruction is to inhibit the vast and strong movements of the body which anger may induce. This is *perhaps also (apart from the motive discussed in chapter 2) why Michelangelo is apt to keep his figures, single or grouped, within a narrow and rectangular area.* "[In] Michelangelo's figures . . . [there is] an . . . accentuation of what might be called the 'basic directions of space.' Oblique lines tend to be replaced by either horizontals or verticals; . . . foreshortened volumes tend to be either frontalized or orthogonalized . . ." (Panofsky 1939, 172–173). "Underlying Michelangelo's forms" there is "always" a "block shape" (Hartt 1964, 150). "[The Bologna Angel] is enclosed within straight lines meeting at right angles" (Weinberger 1967, 52). When the Manchester Madonna is attributed to Michelangelo, it may be recalled that "characteristic of his imagination is the fusion of the seven-figure group in a . . . slab almost . . . square" (Steinberg 1980a, 443). In The Medici Madona "the most vehement movement is . . . contained within straight . . . outlines" (Weinberger 1967, 321). In The Last Judgment "most of the figures . . . keep, in their movements, to the limits of an imaginary rectangular block" (Wilde 1978, 167). In the Crucifixion of St. Peter "each of the figures is . . . a rectangular block" (op. cit., 170); and "the . . . groups—the soldiers at the lower left, the horsemen, the friendly chorus at upper center, the marchers in echelon descending at right, and the huddle of women below—all form . . . rectangular units" (Steinberg 1975a, 51). In the late drawings "their [the figures] silhouettes become . . . sometimes almost rectilinear" (Tolnay 1960, 79).

*From the same obscure motive, movements of figures are apt to be limited, and their poses thus compact (see again chapter 2 for another factor).* "From the hips upward" The Medici Madonna is "unmoved," and "movement limited to the extremities

of the body is . . . also found in Night and Day . . ." (Weinberger 1967, 322). The Last Judgment poses, "with inhibited forward and reverse movements" show "compactness" (Hartt 1970, 288).

Presenting figures fettered *(legato)*, Michelangelo no doubt intends us to think also of "the . . . human soul held in bondage by its desire" (Panofsky 1939, 194). Or, perhaps less clearly, desire held in bondage by the soul. In contrast to "the free *and* violent actions of The Battle of Cascina" the Slaves are each "a figure that cannot move from its position" (Hartt 1970, 62).

Fighting against his anger, Michelangelo is apt to attribute uninhibited destructiveness to others. In contrast to his own good *gigante,* the David who, like the Brutus, limits the completion of his rage in killing to a morally justified, even commanded act— Michelangelo imagines a giant evil not fully in intent, but wholly in effect: "There is a giant . . . where his foot has trodden he has crushed . . . a town repeatedly. . . . [With his foot] he makes a plain of every mountain . . ." (Gilbert no. 68, ll. 1–16). Another being who knows what he does, "kills those standing near him with a look, only to show he's on a pleasant round . . . his fine fair eyes making the sun grow dark . . . whose song and frolic strikes others dumb . . ." (Gilbert no. 73, ll. 2–7).

A fear of being murdered coalesced in Michelangelo with fearing other kinds of death: the fear of dying from merging with mother (chapter 2); the fear of being unable to survive as a fragment from the infant's initial unity with the mother, prematurely broken by her (chapter 2), or even as an already separate being, a child still unable to sustain himself when abandoned by his caretakers (chapter 3).

*Obscurely, Michelangelo may have wished to die so as to be reunited with his mother (chapter 2), as well as with his father:* a possible motive for the depiction in The Deluge of a son's corpse being carried by his father (Liebert 1983, 31) as well as for the fantasy of dying together with his father (quoted in chapter 4). *But the wish to die may have fostered a fear of yielding to it.*

Michelangelo expressed fear of death with an intensity and a frequency which were, in my guess, well above what was customary in his milieu.

So he did his attempts to allay his fear.

He may present delaying death as the principal objective of life. "I am . . . plodding along *(mi vo afaticando)* . . . in order to prolong my life as long as I can" (letter to Martelli, January 29, 1542. Ramsden no. 212). "Do your best to live as long as you can" (letter to his nephew, April 25, 1556. Ramsden no. 413).

In order to prolong life, keep to your own affairs! "Buonarroto," he writes his preferred brother in Florence at the time of the sack of Prato, "I learned from your last letter that the Territory [of Florence] was in great danger. . . . So stay quietly and do not make friends or intimates of anyone . . . and do not speak either good or evil of anyone, because no one knows what the outcome will be" (September 18, 1512. Ramsden no. 81). "That . . . man who . . . said I did not concern myself with public affairs," he lies to this brother's son a third of a century later, "spoke the truth" (November 5, 1547. Ramsden no. 292): thus he forsakes his benefactors and friends among the Florentine *emigrés* on behalf of survival, as he had already in his attempt to placate Baccio Valori in 1530.

Life requires flight. "Oh lovers, run from love, run from the fire, the flames are cruel and the wound is deadly. . . . At the first glance, do not lag back, but run" (Gilbert no. 25, ll. 1–9). "Here I am," he has the dead Cecchino Bracci say, "of the *Bracci* [arms], and too weak to fight against my death and so not die. Better if I had been of the *piedi* [feet] to flee than to be of the *Bracci* and yield to the attack *(non far difesa)*" (Gilbert no. 182). "Act as in the case of plague," he advises his brother, at the time of the sack of Prato, "be the first to flee" (letter to Buonarroto, September 5, 1512. Ramsden no. 80). Thus Michelangelo acted, fleeing from Florence to Bologna (1494), from Bologna to Florence (1495), from Rome to Florence (1506), from Florence northward (1529), from Rome southward (1552).

I don't need to fear death because I am dead already: "I live [in my house in Rome] in my tomb" (Gilbert no. 265, ll. 1–4).

"Marvelous," the late Michelangelo advances, is "the effect

of thinking of death." While "death by its nature destroys all things," the thought of it "preserves and maintains," "protecting against all human passions": "no other thing defends us better than the thought of death" (Giannotti, 69): it is desiring and raging which destroy the self.

While Michelangelo in words and works flees from the pain, the wounding and the annihilation of the body, he embraces the sufferings of his soul.

Of course he complains about them. Michelangelo abundantly presents himself as dismayed by his *miseria* which then appears to him as imposed on him by mostly unnamed agents (chapter 7). Some power has condemned him to hard labor for life (*for some unknown crime?).* "Such is the way in which I am living here," he writes his preferred brother in his early thirties, "that if you knew what it's like you would be appalled" (January 5, 1508. Ramsden no. 39). "I am living here in the greatest discomfort and in a state of extreme fatigue; I do nothing but work day and night . . ." (letter to Buonarroto, November 10, 1507. Ramsden no. 37). More than forty years later he exclaims to that long dead brother's son "what a miserable life of toil I lead . . ." (March 2, 1549. Ramsden no. 322).

Michelangelo elaborates upon his preference for displeasure in his poetry where he can use Petrarch's themes.

He insists upon preferring pain. I would miss it were my beloved to stop hurting me. "If you," the loved and unloving other, "should ever remit my dying and my anxious sighs, I'd feel my heart . . . missing my many agonies" (Gilbert no. 114, ll. 6–10). "If she enjoys and you, Love, only live upon our grief, and I . . . support my life with aching heart, with tears . . . and with ice, . . . we'd be deprived of our lives by a goodly lady's grace . . ." (Gilbert no. 143, ll. 1–6). "Does anyone live only . . . on pain and on his sufferings as I?" (Gilbert no. 72, ll. 3–4). "The death and the pain I seek and want . . ." (Gilbert no. 43, l. 10); "the harm I wished and want . . ." (Gilbert no. 52, l. 102). "Humbly I offer the harsh yoke my neck, before the evil luck my

80

face is happy. . . . From no pain do I shrink, but instead always fear it may grow less" (Gilbert no. 136, ll. 1–6).

For "the better one is, the more one suffers" (letter to his nephew, February 21, 1549. Ramsden no. 321). "The most perfect come to the most harm" (Gilbert no. 258, l. 11): pain is not (*as Michelangelo may obscurely feel it is)* punishment and hence proof of crime, but rather evidence of moral worth.

My suffering at your hands disproves my guilt and proves yours. "Against me, lame and naked, setting wings to your bow, your eyes as your banner that murder more than your most painful dart, how shall I be relieved? Not shield or helmet now, only what shows me honor in loss, and blame to you if you will burn me" (Gilbert no. 173, ll. 7–14).

Suffering makes for faith: "God in misery only we adore . . ." (Gilbert no. 294, l. 6).

Present pain promotes future pleasure. "The death and the pain I seek and want, bring me a happy future" (Gilbert no. 43, ll. 10–11). For "one dying to get his belly emptied" "there is more relief the more distress preceded" (Gilbert no. 52, ll. 33–34) (a point indicative of a dimension of Michelangelo which I shall not attempt to elucidate).

Pain *itself* gives me pleasure. Only pain, Michelangelo hints, does; at least pain is more productive of pleasure than joy, as Petrarch knew: "a thousand joys can't match a single torture" (Petrarch quoted in Gilbert no. 249, l. 14). "Bittersweetness is what my . . . thought desires . . ." (Gilbert no. 242, ll. 5–6). ". . . What most die of I only enjoy and live by" (Gilbert no. 134, l. 13). "I get my happiness from my dejection and these disturbances give me my rest; to him who asks it, God may grant ill fortune!" (Gilbert no. 265, ll. 25–27). "Games and delights for me death and abuse" (Gilbert no. 264, l. 8).

If gratification eliminates pain, it also kills desire and hope: "the man who does not lose has least part in the sport if every longing vanishes in pleasure; when a thing satisfies hope has no place to sprout . . ." (Gilbert no. 243, ll. 7–12). "A lover's condition is less happy where . . . excess brings . . . desire to a stop than when his wretchedness is filled with hope" (Gilbert no. 247, ll. 11–13).

Where there is any pleasure, there soon may be too much of it. "If I were to find myself in this company, as it would happen if I had lunch with you," Michelangelo may have said to his closest friends, "I would experience too much joy, and I do not want to feel so much joy" (Giannotti, 67).

Pleasure induces an incapacity to feel. "If you . . . with too much pity make me be serene, more than my tears it seems to leave me lifeless" (Gilbert no. 148, ll. 5–8).

Pleasure induces loss of mastery over oneself. "My sails collapse so in . . . fair weather that my frail boat, without a wind at sea, loses its pathway and appears to be a bit of wood in the rough water" (Gilbert no. 297. ll. 5–8).

Pleasure *(orgasm?)* causes death, while I won't die from suffering—which assures me of being in no danger from its opposite: "great pain would have me live . . ." (Gilbert no. 43, l. 16). "Your beauty . . . to have me live must check this great content; my feeble powers surpassing bounty kills" (Gilbert no. 148, ll. 12–14). "When sometimes I am beset by your great mercy, I fear and chafe no less than at your rigor"; "at one extreme or the other" the wound from the blows of love is deadly" (Gilbert no. 324). "Lady, with surer safety less graciousness would keep me living yet. . . . My little strength by double courtesy is so outmatched, it is shadowed and suppressed. No wise man ever wished . . . greater joy than he could handle. . . . In the excess of pleasure death is contained" (Gilbert no. 146, ll. 1–15).

Particularly when pleasure follows upon its protracted absence. "Great mercy no less than great distress, Lady, is death for a convicted man, empty of hope, frozen in every vein, if he is suddenly set free . . ." (Gilbert no. 148, ll. 1–4).

I enjoy suffering because you enjoy making me suffer. "The more I seem to feel my ills are great, if my face lets it show, it makes your beauty grow greater . . . so that the pain turns sweet. My torturer [Love] does right if he makes you beautiful . . . through my . . . woe. . . . If I were dead, what would you ever do? If it is . . . true [that] your beauty comes out of my . . . distress which, if I died, would cease, when I am dead your loveliness dies too. Let it therefore be so that I live on in pain for your less hurt . . ." (Gilbert no. 121, ll. 1–16). "Since, Love, for

82

joy you would have us . . . suffer, dearer to me is each more cruel dart" (Gilbert no. 135, ll. 1–2).

If I enjoy pain, I avoid fear. "If her . . . face food and life from a great pain supply, what . . . harm can ever make me die?" (Gilbert no. 136, ll. 7–9).

In such ways Michelangelo attempts to make the best of the situation in which he sees himself placed: confronted with the hostility of those on whom he depends for surviving and loving.

# CHAPTER 7

# HERO AND SLAVE

ALONG LINE OF FIGURES by Michelangelo—one has only to think of S. Proculo, David, Moses, Brutus—are heroes. The late Saint Peter shows an extreme of resistance, in body and soul, in extreme adversity (fig. 28).

In his architecture Michelangelo distinctively made members impose burdens on others supporting them—burdens resisted. "Michelangelo preferred the effects of post-and-beam construction [to arches]; . . . He walled up Sangallo's arch over the central window of the Farnese Palace to replace it with a lintel. . . . On the one occasion when he used structural arches on the exterior of a building—at the Porta Pia . . .—he disguised the form. Semi-circular arches have an . . . effect uncongenial to Michelangelo's . . . interplay of horizontal and vertical forces" (Ackerman 1961, 63).

The pressure which Michelangelo made members exercise on others supporting them was distinctively high; so was his sense

85

that the members thus burdened were human. In the Tomb of Julius II according to the contract of 1532 "the positions of the arms and heads of the Academy Slaves . . . turn them into caryatids . . . which have taken over the function of . . . holding the cornice . . . , quivering and straining under its . . . weight" (Hartt 1968, 244). "[In] Michelangelo's earliest design [for the façade of S. Lorenzo] . . . a balance between load and support which Sangallo was concerned to create is disrupted by Michelangelo's emphasis on load . . ." (Einem 1973, 86). In The Medici Chapel "the low door . . . [is] dominated by the taller tabernacle above it. The tabernacles . . . are so heavy that the lintels on which they rest have to be supported by brackets . . ." (Lotz 1974, 243) (fig. 18). In The Farnese Palace, "while in earlier Roman palaces . . . the third storey of the court was . . . lighter than the lower floors . . . Michelangelo conceived it as a . . . load . . . above . . . two lighter floors" (Tolnay 1975, 162). In the Porta Pia "the passageway . . . seems . . . low in comparison with the height and weight of the pediment. The preliminary drawings . . . showed the contrast between a cramped opening and a . . . weighty frame," as "[it] can be seen in the doorways of the New Sacristy" (Lotz 1974, 260).

As a project developed, Michelangelo was apt to heighten burdens. "The lower part of the monument [the Tomb] . . . was already, in the project of 1516, dominated by the . . . burden of the upper storey. . . . In 1532 the artist had further accentuated this . . . weight . . ." (Tolnay 1954, 63).

So heavy must a burden be that its bearer may seem to be crushed, yet is not (as Bacchus may seem to be losing his equilibrium, yet does not; see chapter 2). In the upper part of the project of 1516 for the Tomb and the drawing after the model for the façade of S. Lorenzo "the weight which the lower story has to carry has been increased to an almost menacing degree"—which "is, perhaps, the only feature in the façade project that unmistakably reveals Michelangelo's . . . spirit" (Wilde 1978, 105–106). Generally, in the projects for that façade "Michelangelo . . . tries to make the weight predominate over the supports. He plans the ground floor colonnade on barely elevated bases, raises the attic

86

. . . [which] threatens to crush the . . . ground floor" (Tolnay
1975, 129).

Let others predict that the bearer will be crushed by his as-
suredly huge burden, and let them be proved wrong! The "mass
of ornamentation" in the Farnese cornice "led Michelangelo's op-
ponents to proclaim that the building could not stand the weight
. . ." (Einem 1973, 193).

When the bearer *is* affected by his burden, he does not lose
form but only acquires an even more desirable one: in The Medici
Chapel "weight and movement of the Times of Day seem to be
the . . . cause of the splitting of the sarcophagus lids. . . . In The
Porta Pia . . . the segment seems to break apart under the weight
of the . . . pediment" (Tolnay 1948, 166). The vanquished is the
victor.

If a light object is not crushed by a heavy one bearing down
upon it, it shows the capacity of a David to withstand a Goliath.
The "colossal imaginary structure" of painted architecture in the
Sistine ceiling is "poised" on simulated rams' skulls. "Of all the
prophets and sibyls . . . only Ezekiel and Cumaea . . . and Jonah
. . . rest their weight on both feet. The other nine appear to be
balanced on one foot. . . . So do all but two of the . . . ignudi.
In the . . . single figures, therefore, is recapitulated the principle
of a great weight . . . poised upon a small fulcrum, which prin-
ciple activated the scaffolding [a deck joined by beams—*sorgoz-
zoni*—to the wall]. . . . The scenes in all four spandrels are simi-
larly perched upon tiny points. In the . . . preparatory drawings
these . . . fulcra, especially feet and even toes, are . . . studied
with fanatical care, often repeated for more careful investigation
of the . . . effect of . . . stress. . . . [Similarly] the huge . . .
statue of the Madonna envisaged in the . . . projects for the Tombs
of Julius II . . . in 1505 . . . seems to soar . . . must have been
attached . . . at the back. The finestre inginocchiate of the Medici
Palace, the tabernacles of the Medici Chapel, the . . . fictive ar-
chitecture of the ricetto of the Laurentian Library, the upper story
of windows of the Farnese Palace are all supported . . . on . . .

87

volutes providing the . . . kind of toehold into the wall on which the sorgozzoni rested" (Hartt 1982, 282).

There are, in Michelangelo's presentation of his life, moments which show him resisting in difficult situations. When he finds himself "expelled" by the Pope from the Vatican, "I went home and wrote to the Pope, saying '. . . if You want me, You must seek me elsewhere than in Rome'. . . . I . . . set out for Florence. The Pope . . . sent five horsemen after me; they caught me up . . . and gave me a letter from the Pope which said 'Immediately upon receipt of this, return to Rome, upon the pain of Our displeasure . . .' I made answer to the Pope that whenever he discharged his obligations toward me, I would return . . ." (letter to an unnamed Monsignore, October/November 1542. Ramsden no. 227)—In his early adolescence, Michelangelo told Condivi, he "abandoned the study of letters. On this account he was . . . often beaten . . . by his father and his father's brothers. . . . The . . . distress this caused Michelangelo . . . was . . . not enough to turn him back [from drawing and painting] . . ." (9).—Michelangelo remembers, presumably with pride, Piero Soderini's assessment of his conduct when leaving Rome in 1506: "You have tried the Pope as a King of France would not have done" (Condivi, 37)—While working on the Sistine ceiling "Michelangelo," so he tells Condivi, "wishing to go to Florence for the feast of S. Giovanni, asked the Pope for money. When the Pope demanded when he would finish the Chapel, Michelangelo answered in his usual way, 'when I can.' The Pope . . . struck him with a staff. . . . After Michelangelo had gone home, he was making preparations to go . . . to Florence when . . . a young man much in favor arrived from the Pope and brought him five hundred ducats . . . making the Pope's excuses. Michelangelo accepted the apology and went off to Florence" (59)—Because it [painting The Last Judgment on the altar wall of the Sistine Chapel] had been Pope Clement's idea and begun in his time, Michelangelo did not put Paul [III]'s coat of arms in this work although the Pope had besought him to" (Condivi, 83)—As to "the building of St. Peter's," "Michelangelo has never wanted anything in

88

return for this service. . . . When the Pope sent him a hundred scudi . . . Michelangelo sent them back. . . . The Pope was angry . . . but not even on this account did Michelangelo change his mind" (loc. cit., 101).

Only under overwhelming pressure does Michelangelo, he suggests, abandon resistance. "He was interrupted [working on the Tomb]", Michelangelo alleges to Condivi, "to his great distress because Pope Leo . . . conceived a desire to decorate the façade of S. Lorenzo. . . . He wanted him . . . to take on that whole burden. Michelangelo . . . put up all the resistance he could, alleging that he was under obligation to Cardinals Santi Quattro and Aginense [Julius' heirs]. . . . But the Pope . . . made them release Michelangelo [who] . . . weeping left the tomb . . ." (59–60). Michelangelo having fled to Florence disobeying the Pope, "Julius sent three briefs to the Signoria [requesting his return to Rome]. When the last one arrived, the Signoria sent for me and said 'We do not propose to go to war with Pope Julius over you. You must go . . . we will give you a letter of such authority that if he does you any harm, it will be done to this Signoria.' Thus ordered I returned to the Pope" (letter to an unnamed Monsignore, October/November 1542. Ramsden no. 227).

Michelangelo's several stories about an event may show how he changes submission into successful resistance. Less than two decades later he recalls about this voyage to Bologna that "I was forced to go there with a rope round my neck" (letter to Fattucci, December 1523. Ramsden no. 157). For Condivi he evokes a different scene. "When he [Julius] saw Michelangelo . . . he said to him. . . 'You were supposed to come to Us, and you have waited for Us to come to you' . . . [to] Bologna . . . much closer to Florence than Rome. Michelangelo knelt down and loudly begged his forgiveness, pleading that . . . he could not bear to be turned away as he was. The Pope remained with his head bowed and a disturbed expression on his face, answering nothing, when a Monsignor sent by Cardinal Soderini to . . . recommend Michelangelo . . . said: '. . . He offended through ignorance. . . . Painters . . . are all like that.' To which the Pope answered . . . 'You are saying insulting things about him which we do not say. You are the ignoramus and the wretch, not he. Get out of my

sight and go to the devil.' When he did not go, he was pushed out . . . with jabs by the Pope's attendants . . ." (38).

Probably Michelangelo is so eager to elaborate on the incident cited so as to furnish a counterpoint to his penchant for submission, for the state of lying prone beneath an erect man such as in The Victory (fig. 29). This is what he *wants:* "I offer the . . . yoke my neck" (Gilbert no. 136, l. 1); "if . . . defeat must be my joy (*se vint' . . . debb'esser beato . . .*)" (Gilbert no. 96, l. 12)—while the victor in The Victory is pensive rather than triumphant (fig. 29): "Victory is like an enemy" (Gilbert no. 310, l. 2). Michelangelo may imagine a situation remote from the realities surrounding him in which he could justifiably aspire to submitting. "Dearest father . . . You must realize that I too have expenses and troubles. However, what you ask of me I'll send you, even if I have to sell myself as a slave" (August 19, 1497. Ramsden no. 3).

Acting *on* the material from which he creates a work of *art,* he demands to be *acted upon* in *life:* "Lady . . . draw upon me from without, as I do on white page or on a rock which, having nothing in it, takes what I like" (Girardi no. 111, ll. 1–13).

Michelangelo *probably sensed a rarely expressed urge to force his will on others as well as a belief in his high power to do so.* "[Lady] if you were made of rock, by loving you . . . I could make you come with me. . . . I could make you speak if you were dead. Were you in Heaven I would pull you back . . ." (Gilbert no. 52, ll. 1–6).

*Probably anxious and guilty about how he desired to exercise such power, he denies both its existence and his eagerness for acting upon an other rather than being acted on by him.* Immediately after the passage just quoted Michelangelo reverses himself: "with you there is nothing I can do but follow . . . for you are not fashioned like a tailor's dummy . . ." (Gilbert no. 52, ll. 9–11); rather "I . . . must often beat my breast and know how strong you are against my will" (Gilbert no. 3, ll. 3–4).

Michelangelo presents himself prominently as forced against his will by somebody or something (Liebert 1983, 143). "I keep repeating the time that I have passed, and in it all do not discover

one day that was mine" (Gilbert no. 49, ll. 13–14). "Who is it bringing me to you by force, alas, alas, alas . . . ?" (Girardi no. 7, ll. 1–2). In a draft of a letter reviewing the past Michelangelo said correctly that in 1505 he "went (io andai)" from Florence to Rome "to stay with" the Pope. In the letter itself this becomes "the Pope taking me away (levandomi)" (Draft of a letter to Fattucci, December 1523, letter of January 1524. Tolnay 1954, 82 and Ramsden no. 157), as Ganymede is lifted away by the eagle. Michelangelo perceives himself as "carving holy things" not only "with so much boredom," but also "with so much slavery" (Gilbert no. 280). "Pope Julius," he recalls decades later, "decided not to have the Tomb done in his lifetime, and set me (messemi) to painting. Then he kept me (mi tenne) in Bologna for two years . . ." (letter to an unknown Monsignore, October/November 1542. Ramsden no. 227). In a sonnet on his work on the Sistine Ceiling he presents himself as doing what he does not want to do, painting a ceiling rather than carving a block of marble: "I am not in a good place, and I am no painter" (Gilbert no. 5, l. 20); somebody has forced him. "When he had . . . completed The Flood, it began to mildew . . . . Michelangelo . . . said to him [the Pope], 'I told Your Holiness that this is not my art . . . .' . . . he was forced to continue . . ." (Condivi, 57). "I was forced (fu messo a forza)," he affirms almost half a century later and in the face of contrary evidence, "to undertake the work on the fabric of St. Peter's . . ." (letter to Vasari, May 11, 1555. Ramsden no. 398). "Ten years ago I was put in charge of the fabric of St. Peter's by Pope Pagolo, under duress (con grandissima forza) and against my will . . ." (letter to Vasari, May 22, 1557. Ramsden no. 434). "I have served three Popes. . . . It has been under compulsion" (letter to his nephew, May 2, 1548. Ramsden no. 306).

Michelangelo often presents the force used on him as physical. "I am chained (legato) to the Tomb" (letter to an unnamed Monsignore, October/November 1542. Ramsden no. 227).

On a rare occasion he hints at the motive making him choose an act which he nevertheless affirms to have been forced, as an other imposes that motive on him; an other who may be imaginary. When he left Florence in 1529, Michelangelo seems to have at least in part believed, it was not that he wished to safeguard

his fortune which he took with him, but because somebody forced him on behalf of that supreme objective, survival (chapter 6). "On Tuesday morning, the twenty-first day of September, someone came out from the San Niccolo gate to the bastions where I was and whispered in my ear that to remain any longer would be to risk my life. And he came home with me where he had dinner, and he brought me mounts and never left me till he *got me* out of Florence. . . . Whether he were god or devil I know not" (letter to Battista della Palla, late September 1529. Ramsden no. 184)— In the declining days of Piero de'Medici, Michelangelo tells Condivi more than half a century later, "a . . . man nicknamed Cardiere . . . confided to him a vision . . . : Lorenzo de'Medici had appeared to him . . . commanded him to tell his son that he would soon be driven from his house [in which Michelangelo lived]. . . . Another morning . . . Cardiere . . . once again tells him that Lorenzo appeared to him that night . . . and . . . struck him . . . on the cheek because he had not communicated to Piero what he had seen. . . . Cardiere . . . set out . . . to go to Careggi. . . . He met Piero. . . . He disclosed all that he had seen and heard. Piero laughed it off and, alerting his attendants, made them mock him. . . . When he was at home again, . . . he spoke to him [Michelangelo] so convincingly of the vision that he . . . left Florence . . ." (Condivi, 17–18).

It is exceedingly rare for Michelangelo to reject his inclination to feel forced: "Accursed be the day in which I went. . . . Did I not know no hearts by days [the stars] are bound and no souls forced by them or adverse winds against . . . our own freed judgment?" (Gilbert no. 68, ll. 19–23).

*When I am forced, I can at least be sure not to have been abandoned.* Michelangelo may prefer the Julius who forces him to rejoin him in Bologna after his flight from Rome to the Julius who "expels" him from the Vatican.

*To be forced is to be overwhelmed physically by bodies of men:* *an imagination in which Michelangelo may obscurely take pleasure.* "In the Hercules and Antaeus and in the Samson and Two Philistines of the 1520s Michelangelo had developed more closely knit groups. By 1533 . . . the opponents . . . became en-

closed within the outlines of the victors" (Weinberger 1967, 268).
"The composition of two entwined figures breaks . . . with the
. . . separate figures common to . . . statuary groups of the ear-
lier Renaissance. This . . . interweaving of human forms . . .
springs from Michelangelo's . . . interest in wrestling males, to
be found as early as the Battle of Lapiths and Centaurs and reap-
pearing throughout his . . . pictorial compositions" (Hartt 1968,
263). They wrestle to the death instead of to the pleasure; yet the
victor's body impinges on the victim's; that, for Michelangelo, may
be the point.

*Forced, I become a *servo in forz'altrui* (Girardi no. 267, l. 54.)*
"It is not in my power to refuse Pope Pagolo *anything*" (letter to
an unnamed Monsignore, October/November 1542. Ramsden no.
227). "Alone" and "naked" Michelangelo imagines himself "pris-
oner" of the "armed cavalier." That I cannot prevent him from
doing anything he pleases to me is "blessedness *(essere beato)*" for
me (Girardi no. 98. ll. 12–14).

Perhaps he will choose precisely what I myself desire to hap-
pen, and which I will then obtain at the cost of less fear and guilt.
Wishing to "burn like dry wood" (Gilbert no. 94, ll. 1–2), Michel-
angelo points out about "my heart's fire-setting thief" that "he is
to blame who fated me to fire" (Gilbert no. 95, ll. 12–13). "The
drawing which Michelangelo . . . made for . . . Tommaso . . .
shows Ganymede . . . without a will or a thought of his own
. . . the posture of his arms suggesting . . . an unconscious per-
son or a corpse . . ." (Panofsky 1939, 216)—or even one fully
alive who can allow himself pleasure for which he is not respon-
sible (fig. 30).

To love is to be made to love him by the beloved, which is to
be "bound" by him. "How many times you've bound . . . my
. . . limbs . . ." (Gilbert no. 21, ll. 5–6). These fetters are not
physically constraining; the many bonds drawn, painted, carved
by Michelangelo are not. That they are not thrown off *probably
expresses both the lover's wish to have the beloved one do with
him that which he pleases and his refusal to acknowledge that
wish.* "Who is . . . bringing me to you by pressure *(forza)*, alas,
alas, alas, though I am loose *(sciolto)* and free, bound up so tightly

93

(stretto)? If you can fetter us without a fetter (catena), and without using hands or arms have caught me, against your beautiful face who will protect me?" (Gilbert no. 7).

*Or against your beautiful body? But, precisely, I may prefer to lack the ability to protect myself. Such a position promises more pleasure and less guilt, and because of that merely assuming it gives pleasure.* "She . . . binds me . . . seems like sugar to me" (Gilbert no. 309). In The Dying Slave "the position of the arm is forced upon the youth (fig. 31); yet there is in this an air of abandon that recalls the similar gesture of the ignudo at the right of the Libyan Sibyl . . ." (Weinberger 1967, 171)—and Ganymede (fig. 30) finding pleasure in the eagle's abducting members, as well as Tityos (fig. 32) in the vulture's gnawing one.

## CHAPTER 8

# LOOKING AND TOUCHING

IN A POEM "which seems to be dedicated to Cavalieri" (Girardi 1960, 185) Michelangelo attributes to himself *"far ben mal"* (Girardi no. 104, l. 11); in another just *"mal,"* "free, understood, accomplished, true" (Gilbert no. 49, l. 32).

But he does not name any particular deed.

Possibly because "my soul . . . disquieted finds in itself no cause but some great sin unknown to it . . ." (Gilbert no. 278, ll. 1–3); and/or because Michelangelo perceives the badness of his *essence* (chapter 5).

But then Michelangelo declares that in "my heart" there is "vicious (*rio*) thought" (Gilbert no. 32, l. 4); that he is full of bad *habits*—not named—which impose themselves on him: "I cannot change old ways . . . that with more age push and compel me more" (Gilbert no. 159, ll. 9–10). Such are "my bad habits" (Gil-

bert no. 299, l. 5), my "wretched foolish habit" (Gilbert no. 295, l. 1), my "evil wish" (loc. cit., l. 4). Only death can remove it: "In no way else can you take out of myself, my love, my dangerous . . . emotion than by strange happenings and adverse fortune whereby you loose your chosen from the earth" (Gilbert no. 300, ll. 1–4).

"Accursed was the day on which I went with the sign that was running up in Heaven" (Girardi no. 70, ll. 19–20).

At one occasion only Michelangelo discloses more: his "art" is "laden down with sin" because it was "a monarch for me and an idol" (Gilbert no. 283, ll. 6–7).

In my surmise *about the reticence of the penitent Michelangelo, what he felt to be a chronic deadly sin was sexual desire for men whether never acted on, or rarely, or often.*

Several times Michelangelo may be alluding to the sexual nature of his badness. "Fate and chance and fortune . . . allotted to me the darker span *(il tempo bruno)*" (Gilbert no. 102, ll. 5–7); night—which Michelangelo names in the further course of this poem—has largely sexual connotations for Michelangelo (chapter 9). "Filled with sin, bad habits having roots in me and power. . . I feed my heart on poison. The strength that I would need I do not own to make my luck, *love*, life, and customs alter . . ." (Gilbert no. 291, ll. 1–6): among the last four nouns *amor* is the only one with a particular object. Michelangelo acknowledges depraved *(pravo)* desires (Girardi no. 254, l. 8). What the "sin *(colpa)*" is which "is driving my spirit to great grief," he begins a sonnet, is "to me a secret." But he continues thus: "my senses *(senso)* and their own fire *(ardire)* have bereft all . . . peace from my heart" (Gilbert no. 298, ll. 1–4). In The Dream "around the central figure appear . . . representations of . . . vices. . . . The figures symbolizing lust are . . . the largest and . . . most numerous of the groups" (Testa 1979, 53).

In The Fiery Serpents "youths . . . try to free themselves from the coils and bites of the serpents which rather resemble . . . embraces and kisses (. . . the serpent was a symbol of . . . lust)" (Tolnay 1955, 98) (fig. 17). In Tolnay no. 267 r "the struggle [between two men] . . . transforms itself into an embrace . . . ."

96

Beauty—for Michelangelo principally that of the male body in reality and in art—is a manifestation of God. This Michelangelo believed until the mid-1530s.

Indeed, beauty is God's only manifestation: "we have no other fruit, no other token of Heaven on earth" than "all beauty that we see here" (Gilbert no. 81, ll. 9–13).

"Any beautiful thing carries from the world toward God a desire that is good *(il buon desio)*" (Girardi no. 117, ll. 1–3).

For a desire toward a beautiful other to be good it must be directed toward him as a manifestation of God: "God . . . shows himself nowhere more to me than through some veil, mortal and lovely, which I will only love for being his mirror" (Gilbert no. 104, ll. 12–14).

What distinguishes good from evil desire for a *cosa bella*, principally, for Michelangelo, a beautiful male?

"Of a six forces of the soul," Michelangelo probably believed with Ficino, "three belong to . . . matter: . . . touch, taste, and smell. And three belong to the spirit: . . . reason, sight, and hearing" (Ficino, 62).

Taste is little involved in a relation with an other; smell and hearing seem to have been little charged by Michelangelo in such a relation. There remain good "reason" (nobility of soul, for Michelangelo), good seeing—and bad touching.

The nobility of the other's soul may be shown by his possessing a "divine head": "I see within your beautiful face: . . . your soul already, still clothed in its flesh, repeatedly has risen with it to God" (Gilbert no. 81, ll. 1–4).

There is for him, Michelangelo observes, no loving without seeing: "it is difficult to love well what cannot be seen" (Girardi, Appendix no. 26).

But no love is good which goes beyond the delight of seeing; the desire to touch is bad. "The lover of the body is content with seeing only: the lust of touching is lasciviousness . . ." (Ficino, 36). "Unreined desire, not love, our senses are, killing the soul . . ." (Gilbert no. 103, ll. 12–13).

When an other lacks all beauty—of body, head and spirit—Michelangelo might still wish and practice intimacy of board and

bed with him. In Bologna 1506–1508 "he hired a single room with one bed in it where . . . he slept together with his three assistants. . . . Such . . . habits prevented Michelangelo from inspiring his subordinates with . . . respect. The want of control over servants and workmen . . . is a noticeable feature of his . . . life. . . . He soon got into trouble with the three craftsmen he had engaged to help him. . . . Lapo d'Antonio di Lapo, a sculptor at the Opera del Duomo . . . boasted that he was executing the statue [of Julius the Second] in partnership with Michelangelo and upon equal terms, which did not seem incredible considering their association in a single bedroom" (Symonds 1893, v. 1, 189).

When the other has beauty of torso and limbs, but no beauty of face, or beauty of face but none of spirit, Michelangelo seems capable of not perceiving, or of pretending not to recognize the other's lack, so as to enjoy what he does possess; witness his correspondence with Febo. Michelangelo seems to take it for granted that *others* will attribute sexual desire for a beautiful adolescent *body* to him. When a father attempts to induce Michelangelo to hire his son as a *garzone*, "saying that if I were but to see him I should pursue him not only into the house but into bed," Michelangelo's reaction in a letter to an assistant is mild: "I assure you that I will *deny* myself that consolation, which I have *no wish* to filch from him. Therefore will you get rid of him for me? I am sure you'll know how to do it, and will do it in such a manner that he won't go away disgruntled" (letter to Tribolo, September 1533. Ramsden no. 195).

In his poems—so largely on loving—Michelangelo does not mention the body of the beloved, but talks much about his face and eyes. Conversely, in his art he often seems more interested in torso and limbs than in the head: to him "faces are of . . . less significance than torsos" (Stokes 1955, 86). *Probably his sexual desire for torsos, a desire dismaying to experience and to satisfy in life, could be expressed in art where he did not need to fear that he would pass from looking to touching.*

Michelangelo seems to have been torn between extremes in the proportion between head and body. The marble David, the Moses, the Accademia Slaves have large heads (Tolnay 1948, 44;

98

Tolnay 1954, 61). On the other hand when in The Death of Joram Michelangelo presents "the 'classic' type of horse," it seems to be expected by the observer that "with Michelangelo the head is . . . smaller" (Tolnay 1955, 73). Eve's body is "voluptuous"—and her head "quite small" (op. cit., 31). The Minerva Christ has "a powerful torso with a small head" (Tolnay 1948, 95); in The Medici Chapel the figures have "small heads" (Hartt 1968, 179).

"He [Michelangelo] finished very few male heads . . ." (Hibbard 1978, 98). In The Battle of the Centaurs and Lapiths "characteristically . . . the most finished portions are the torsos; the heads frequently remain mere masses of rough stone, and the feet are . . . enmired in the surrounding marble . . ." (Hartt 1968, 52). As to the Academy Slaves, "in all four status, Michelangelo's chief interest lay in the torsos, which are from the front at least fully developed . . . and lack only surface finish. Sometimes an arm or a leg is brought to a similar condition, but never a head" (op. cit., 251). In The Rebellious Slave "the face seems to have held less interest for the artist than the body. . . . The face has not received its final treatment. . . . The body . . . except for a few passages . . . is finished and polished" (op. cit., 147–148). In the Minerva Christ Michelangelo "was less interested in the execution of the head . . ." (Tolnay 1948, 90). In The Day Michelangelo "abandoned it [the head] . . . merely roughed in" (Hartt 1970, 178).

In Hartt no. 17 "a scraggy middle aged" head is set upon a "youthful torso": as if to proclaim the possibility, or even the wish, to enjoy the torso alone.

In Hartt no. 30 "the head, like so many . . . heads in Michelangelo's figure studies, was left for separate treatment"; "heads were generally the subject of separate drawings . . . not necessarily from the same model who posed for the figures" (Hartt 1970, 78). The figures in the drawings for The Battle of Cascina "all are . . . headless or show only the backs of heads. The faces must have been drawn separately, as . . . in the drawings for The Sistine Ceiling and The Last Judgment" (op. cit., 45). Michelangelo may thus have set apart the faceless targets of his desire.

99

When the beloved one has all perfections—of body, head and spirit—"we react most vehemently": a law of loving enunciated by Ficino (p. 19) which Michelangelo could test only in one case and then confirm; experiencing then also the fear of being destroyed by strength of feeling (chapter 6): "I was prompted to write to your Lordship," he plans to explain to Cavalieri, "being the first to move, thinking, as it were, to cross a little stream dry-shod, or rather what was apparently . . . a ford. But after I left the bank I found it was . . . the ocean, with its overarching billows . . . ; . . . had I been able I would . . . have returned to the bank . . . to avoid being . . . overwhelmed (sommerso)" (letter, January 1, 1533. Ramsden Draft 4).

It is when the beloved possesses all perfections that the desire to touch him is most evil. If, according to a feeling of Ficino's which, in my surmise, Michelangelo shared, "love not only does not desire . . . the pleasures of . . . touch, love abominates them" (p. 17), it does so the more the higher the worth of the beloved. With regard to a beloved perfect in all respects, Michelangelo expected, in my surmise, the desire to look should most easily predominate over the wish to touch. The beloved one will help me to avoid polluting him to a degree proportionate to his worth. "Her beautiful features summon upward from false desire" (Gilbert no. 233. l. 8). "My eyes . . . can . . . see your . . . face . . . but feet are not allowed to carry there my arms and either of my hands. . . . The soul . . . rises up through the eyes . . . to your . . . beauty: yet so great a fire gives no such privilege to the body of man. . . . Then *make my body all one single eye*" (Gilbert no. 164).

Not only will the perfection of the beloved do away with the desire to touch him, it will also foster loving God through loving this manifestation of his. "The soul . . . through you has come to contemplating God" (Gilbert no. 35, ll. 5–6). "My . . . longing cannot fail to see Him in what's mortal in you. . . . My admiration [for you] cannot be parted from eternal beauty, praising Him . . . who is its cause" (Gilbert no. 32, ll. 7–11). "I . . . from far invoke my own approach to Heaven . . . and reach the bait, you, . . . like fish drawn by the line, upon the hook" (Gilbert no. 13,

100

l. 1–4). While "growing hot" for a woman "draws to earth," "violent passion for tremendous beauty . . . draws to Heaven" (Gilbert no. 258, ll. 1–12). When "a . . . glory falls from furthest stars . . . toward them our wish it pulls. . . . A worthy (*gentil*) heart can never have . . . to counsel it more than a face with eyes that resemble them [stars]"(Girardi no. 107, ll. 5–11). The worthier the beloved, the more loving him will prove that "passion for . . . beauty is not . . . an . . . error if it can leave the heart melted . . . so that a holy dart can pierce it. . . . Love . . . is a first step so that the soul will soar and rise to its maker . . ." (Gilbert no. 258, ll. 1–7).

Such expectations of Michelangelo were destroyed by his reactions to Cavalieri.

As Michelangelo found unprecedented pleasure in looking at Cavalieri and talking with him, Michelangelo's sexual desire for him rose, in my surmise, beyond what Michelangelo had known. So far from "the appetite for coitus and love" being, in Ficino's words, "contrary between themselves" (p. 17), he found that each lent force to the other. Ganymede (fig. 30) shows in its conventional interpretation the bliss of the soul carried upward to its home, and visually the orgasm induced in a beautiful young man when penetrated by a mighty being. "If my sensual reaction (*senso*) will let its flame, too scorching, scatter away from your beautiful face to another [of low worth], Lord, it has far less force, as, in its branches, a fierce mountain river" (Gilbert no. 91, ll. 1–4).: Michelangelo may be disclosing to Cavalieri in Rome his simultaneous affair with Febo in Florence. If Vittoria Colonna aroused only spiritual desire and destroyed lust—"her beautiful features summon upward from false desire so that I see death in all other beauty" (Gilbert no. 233, ll. 8–10)—the feelings she inspired were presumably much weaker than those aroused by Cavalieri.

So far from leading him toward God, Michelangelo discovered, his reaction toward this worthiest of men led away from God.

"Hell would hold less pain if by your beauty graced" (Gilbert no. 138, ll. 4–5).

He came to feel and even to accept having two Gods. Upon the prospect of being in Heaven with Cavalieri, he asks, "being with you . . . what can Heaven hold? . . . I could enjoy . . . both Heaven's God and earth's" (Gilbert no. 137, ll. 13–16).

In fact, in Heaven both with Cavalieri and God Michelangelo will "enjoy (fruire)" the latter less than the former: "I shall enjoy God less [than you]. . . . Nothing else can please like your . . . semblance, just as here" (Gilbert no. 138, ll. 1–12).

Finally, Cavalieri becomes Michelangelo's God: "whatever is not you is not my good. . . . [I] desire you as the sole sun. . . . It is not Heaven where you are not" (Gilbert no. 79, ll. 3–13).

While Michelangelo's reaction to Cavalieri thus makes God disappear from his feelings, it leads him toward other men, such as Febo: "I live on fire not just for you, but any who resembles your eyes or brows in any slightest part" (Gilbert no. 79, ll. 8–10). The Archers (fig. 33) may signify the many arousing desire in the herm which shows "an erect phallus pierced at its base with an arrow" (Testa 1979, 62).

Cavalieri, in my surmise, perceived and objected to the sexual character of Michelangelo's reactions to him, and withdrew to a degree. Michelangelo protested that Cavalieri misunderstood him, and urged Cavalieri to return to earlier intimacy. "What my eyes saw was nothing that is mortal when in your beautiful ones I found my peace" (Gilbert no. 103, ll. 1–2). "[Your] immortal form down to . . . earth came. . . . This makes me love, this only lights my flame, and not . . . your . . . outward face" (Gilbert no. 104, ll. 2–6). "Perhaps your spirit, gazing at this chaste fire that consumes me, will . . . have trust . . ." (Gilbert no. 70, ll. 5–7). "To what am I spurred by a beautiful face's power? To rise . . . among the chosen spirits. . . . What blow is it I should expect from justice because I . . . burn with holy thoughts . . . ?" (Gilbert no. 277). "I have come to enjoy you closer by. . . . Why put off our greetings longer? If . . . is true . . . the good desire that's granted me, let the walls set between us fall away. . . . If in you I love only . . . what you love most in you, do not be angry; the one's enamored of the other's spirit. What in your beautiful face I have wished and learned, human intelligence can

102

grasp but badly. He is required to die who wants to see it" (Gilbert no. 58, ll. 2–14).

Michelangelo reacts as he does in the affair of the Tomb of Julius II: he is being calumnied by enemies who attribute their own badness to him; and the beloved accepts such allegations. "How will the chaste wish that burns my . . . heart ever be heard by those who always see themselves in others? For me the precious passing day is crushed with my Lord who gives heed to such a falsehood . . ." (Gilbert no. 56, ll. 9–13).

But then Michelangelo recognizes that Cavalieri is right: "I do not know if it's the wished for light of its first maker that the soul can sense, or whether . . . some other beauty shines into the heart. . . . From whom I do not know what smoldering remnants may be are what now makes my weeping start" (Gilbert no. 74, ll. 1–8). "From an eternal to a short-lived peace . . . I have fallen down. . . . Where truth is silent its survivor, cut off from it, is sensuality (senso)" (Gilbert no. 76, ll. 1–4). Thus Phaëthon (fig. 34) is made to fall down by the youthful Phoebus-Apollo; Tityos (fig. 32), prone, is punished for having desired a divine being by a vulture penetrating—in talion—his body toward the liver, seat of desire (but he may enjoy and wish this—chapter 7).

A high charge of a beautiful body, even or particularly if joined to a beautiful head and spirit, neither come from God nor lead to him. "If an ardent desire (desio) stops at mortal beauty, it did not come down from Heaven. . . . It is sensual desire (voglia)" (Girardi no. 276, ll. 9–11). "However true it is that the beauty of God your beautiful . . . face . . . shows . . . , that distant joy is weak (corto) for me, and your face I do not quit; every other . . . road the journeying soul finds too steep or straight. Wherefore my time I allot, giving the nights my heart attached to you, my eyes the days, and yearning for Heaven no interval. Thus . . . my fate has stopped me in your rays, and no rise permits my burning will. If nothing else can pull my mind to Heaven . . . the heart is late to love what eyes can't see" (Girardi no. 258). "No infirm eye can reach the divine from the mortal" (Girardi no. 164, ll. 10–11).

Surrendering to the pleasure of my eyes, I will desire to touch many: "In an instant there runs from eyes to heart whatever object they believe has beauty; and being so ample and so broad,

the roadway on thousands, much less hundreds, will not shut, of every age and sex; and I feel fright . . ." (Gilbert no. 274, ll. 1–5).

Until the early 1530s the two "longings" of Michelangelo—that of his "eyes" for "beautiful things" and that of his soul for salvation—had found a single path to their fulfillment: "to gaze at *(mirar)* all the beautiful things" (Girardi no. 107, ll. 1–4). Now Michelangelo has to choose between the enjoyment of beauty and the attainment of salvation; he decides for the latter. "The soul that fears and respects what the eyes cannot see keeps me from your fair face . . . far as . . . something perilous . . ." (Girardi no. 268, ll. 5–8). "God . . . make me *(mettemi)* hate . . . the beauties of the world which I honored and worshipped . . ." (Girardi no. 288, ll. 10–13). The Dream (Hartt no. 357) may express this turn (Testa 1979, 56).

No more is there a detour on the path to God: "if ever I feel by mortal beauty burnt," Michelangelo addresses God, "set beside yours I'll think it fire that's spent and . . . I'll be in yours on fire" (Gilbert no. 272, ll. 2–4).

Still, Michelangelo cannot dispense with seeing as a necessary condition of loving. Hence, God, "make me see you everywhere!" (Girardi no. 274, l. 1).

Thus "[the] drawings [presented to Cavalieri] mark the last appearance in Michelangelo's art of . . . male . . . youthful beauty . . ." (Hartt 1970, 248), of the same figure in the same posture in various positions: probably the aging Michelangelo thus imagining himself (Testa 1979, 56). "After the onset of his . . . passion for Tommaso Cavalieri . . . Michelangelo . . . carved only two male nudes . . . both representing Christ . . . emaciated, detached from any . . . physical perfection. . . . His . . . pictorial compositions overflow with nudes, but all are rugged, thick-waisted, and barrel-chested . . ." (Hartt 1968, 35).

"Their faces alone are . . . beautiful" (ibid.). For, I would surmise, Michelangelo had learned that his desire to touch could be aroused by the beauty of any male torso—whether accompanied by beautiful or ugly limbs, head, spirit—but that the ugliness of a torso precluded that desire whatever the beauty of the rest.

Yet such, I would surmise, was now Michelangelo's fear of

104

becoming sexually aroused by a body that he tended to turn away from what had been his sole subject in art.

First, "his very latest works . . . show an incorporeal transparency . . ." (Panofsky 1939, 229).

Second, he turned to architecture.

# CHAPTER 9

# MALE AND FEMALE

"LIONARDO," MICHELANGELO WRITES his nephew whose marriage he attempts to arrange, "if . . . you do not feel physically capable of marriage (*sentirsi della sanità della persona da tor donna*), it is better to contrive to keep oneself alive than to commit suicide in order to beget others" (June 24, 1552. Ramsden no. 371). "Look after yourself," he writes a year later, when the young man has put himself into the danger in question, "because the number of widows is always much greater than the number of widowers" (May 20, 1553. Ramsden no. 381).

Thus the male is vulnerable at night, the time when "man" is "planted" which he "can be . . . only in the shade" (Gilbert no. 101, l. 12). It is also the time when crimes of violence are apt to be committed (see Michelangelo's prediction, quoted in chapter 6, of the sequels to adopting Antonio da Sangallo's plan for St. Peter). At the side of Night is a fearful mask.

Night herself is vulnerable: "she is so weak that anyone can

light a little torch, and take away that much of . . . the night, and she is so foolish that steel and powder leave her smashed and split" (Gilbert no. 99, ll. 5–8). Here it is no more the male who is the victim of the female, but she his: *probably Michelangelo as a child saw in his parents' or foster parents' intercourse the man assaulting the woman, and took the place of both.* Such "anguish" of Night (Hartt 1968, 203) was *probably among the feelings which made Michelangelo forbid himself penetrating a woman.*

And drove him to penetrate, "smash and split" blocks of marble (chapter 2) with powerful auxiliaries of his hands—also at night: for work in the dark he devised a cap of heavy paper supporting a candle.

*Probably Michelangelo retreated from wishing to penetrate to desiring to suck (Liebert 1979, 506); first his mother, then a man.* It is to Cavalieri that he gave a now lost cartoon with an unusual subject: Christ taking leave of his mother (Hartt 1970, 324).

Depicting (chapter 8) a high official of the Curia as the so-called Minos in The Last Judgment and given "the . . . tradition that the damned were to be tormented in those parts by which they had most sinned . . . he has directed the head of Minos' gnawing serpent towards this official's . . . genitals" (Hartt 1964, 148). Michelangelo accepts the sucking child (chapter 1) and rejects the sucked Biagio da Cesena; *perhaps just because he wishes to be acted on in so many ways (chapter 7).*

*Probably Michelangelo desired, obscurely or not, to be penetrated by a man.*

In The Creation of Adam "the mighty right arm of the Lord is . . . naked, as in no other of his appearances in art prior to this time or even elsewhere on the Ceiling. And directly below Adam, the arm of the . . . youth above the Persian Sibyl projects into the scene, coming as close to touching Adam's thigh as the Creator does his finger. . . . The divine figure is convex, explo-

sive, the human is concave, receptive. . . . The Lord is garbed only in a short tunic which reveals the power of his body and limbs" (Hartt 1974, 453 and 450). Having his liver, seat of desire, eaten by a vulture is, to be sure, punishment for Tityos; but as in the case of Minos, punishment for urges of similar kind (chapter 8). Phaëthon's execution for *superbia* (consciously alluding to Michelangelo's daring to love the "divine" Cavalieri) by the thunderbolt of a young Zeus (chapter 8) *may be turning the desire to be penetrated into punishment.* "To fly to the hill *(poggio),*" alluding to the beloved Febo di Poggio, "from which I fall and crash" is "extra boon" beyond the "great sight" of his "beautiful face" (Gilbert no. 98, ll. 5–8). It is indeed an extra boon to be penetrated in a nonsexual manner forever and assuredly: "You came in through the eyes . . . entering me by such a narrow path I can't believe you will ever dare go forth" (Gilbert no. 52, ll. 73–80).

To Michelangelo's stress on the beloved's face in his words corresponds a neglect of face (chapter 8) and stress on the back in his works. In The Virgin of the Stairs "the *back* of the Christ child is turned toward the spectator—something without precedent in . . . Italian art" (Tolnay 1947, 76) (fig. 4). In The Battle of the Centaurs and Lapiths "Perithous, the protagonist, . . . is shown from the back" (op. cit., 77). As to Hartt no. 3, "Michelangelo studied this figure from a Roman sarcophagus depicting the legend of Hercules. . . . In order to get just this back view, the . . . artist looked along the sarcophagus from one end since the original figure . . . is placed in profile." In the Sistine Ceiling "the pair above the David and Goliath spandrel . . . shows two . . . nudes from the rear. This is probably the first time since antiquity . . . that nothing but the . . . back of the human body . . . became an artistic theme . . ." (Tolnay 1955, 71). As to Hartt no. 37, "apparently Michelangelo was not satisfied with this preliminary study, and turned the figure . . . around . . . so that . . . the back muscles could be more clearly observed." In Hartt no. 6 "a . . . succession of muscular contractions and releases" occurs—"especially in the . . . back." "In contemplating the back of Michelangelo's Day we seem to . . . ascend . . . into a cloudy sky" (Clark 1956, 250–251)—for how many fronts is this true?

In the Leda "his [Zeus] tail caresses her buttocks" (Hartt 1964, 46).

Leda's mouth may be sucking and is penetrated: both infant and female.

"Woman is too much unlike [the male]" (Gilbert no. 258, l. 10): *probably Michelangelo obscurely feels too much *like* a woman.*

Reacting against this, he may obliterate the visible distinction between the sexes by presenting women who are masculine, e.g., in musculature. In The Crucifixion of St. Peter "male and female . . . resemble each other so closely that . . . scholars have experienced difficulty in deciding which is which" (Hartt 1964, 55). "The women's breasts have been flattened until they now protrude little more than male pectoral muscles" (ibid.). Vittoria Colonna is "a man . . . inside a woman" (Gilbert no. 233, l. 1).

He does create feminine men. Bacchus has "forms" which are "almost feminine" (Hartt 1968, 68); so has the Christ of the Crucifix in S. Spirito (op. cit., 57). But more often he imagines men who are highly masculine. The two inclinations coexist.

There is slenderness, *probably feminine, and heaviness, probably masculine.* On the one hand there are "the *slender* proportions of . . . the figure in the crucifix in S. Spirito . . . [of] the Christ of the Pietà [in Rome]. . . . There are numerous examples of . . . slender figures in Michelangelo's youthful drawings. . . . The preference for such proportions recurs frequently throughout his mature work . . . and it predominates in . . . the late Pietà compositions . . ." (Hartt 1968, 57–58). The unfinished St. Matthew "would have been . . . slender . . . in the tradition of the David" (op. cit., 132). But The Victory "was . . . intended . . . to contrast in its . . . slenderness with the *heavy* proportions of the flanking slaves" (op. cit., 254). "Just when the reduction [of the Tomb of Julius II] to a simple wall-tomb had proved inevitable . . . around 1532 . . . Michelangelo made one last . . . effort to compensate by plastic power the loss in architectural magnificence. He decided to discard the architecture completed in 1513–1514 . . . so as to make room for four . . . bigger Slaves, which . . . in . . . volume (their depth is greater than their width) have

never been equaled" (Panofsky 1939, 190). But "only in the Christ
Holding the Cross . . . , the . . . Judge of The Last Judgment
and a single Resurrection drawing in Windsor Castle does he [Mi-
chelangelo] confer on Christ . . . athletic power . . ." (Hartt 1968,
82–83). In The Pietà in Milan he probably began doing so—and
then withdrew that quality from Christ, in several stages, to end
up with emaciation (fig. 19) (chapters 3 and 5).

For Michelangelo the big is probably masculine.

Who has attained skill in *disegno*, Michelangelo may have said,
will be able to make figures *taller* than any tower . . ." (Hollanda,
68). He made a *gigante* of David, the antigiant of Kings as well as
of Donatello and Verrocchio. As he progressed on The Sistine
Ceiling the figures expanded in scale (chapter 2). In The Medici
Chapel "the statues grew in Michelangelo's mind as he worked.
In . . . the earliest designs they could have been no more than
half-lifesize. Halfway through the series colossi make their ap-
pearance. Eventually . . . they dominate the architecture and the
space" (Hartt 1970, 166). "In the palazzi on the Campidoglio . . .
the so-called giant order made its first appearance in Roman Ren-
aissance secular buildings" (Lotz 1974, 250). On the same site "the
. . . great *oval*, which contains the oval base of the statue and the
lines . . . radiating from and sweeping back to it make the statue
look far bigger than it is"—an "illusory magnification . . . char-
acteristic of Michelangelo the sculptor" (op. cit., 252).

To Michelangelo *the concave was probably feminine, the
convex masculine.*

"Michelangelo's first drawings for . . . The Last Judgment
. . . [are] not unlike that of Fra Bartolommeo for Santa Maria Nuova
of 1499, with the characteristic difference that Michelangelo's
semicircle of figures is convex" (Wilde 1978, 160–161).

Often his figures are largely composed of "bulging convexi-
ties" (Panofsky 1939, 176), usually set off against yawning con-
cavities. The Day is a "landscape of hill and hollow" (Clark 1956,
250); in Michelangelo "sculptural values are emphasized like the

valleys and mountain ridges of a relief map" (Weinberger 1967, 66). The child's body in The Bruges Madonna shows an "alternation of . . . swellings and . . . depressions" (Hartt 1968, 96). "The Child's body, with all its dimples and hollows . . ." (The Taddei Tondo, Hartt, op. cit., 88). In The Pietà in Rome "each muscular or bony form in the torso and the arms is set off from the others by a pronounced depression . . ." (Hartt 1975a. 49). A wall by Michelangelo is "an . . . alternation of receding and projecting elements" (Ackerman quoted by Steinberg 1975a, note 16). In Michelangelo's buildings there are apt to be "advancing and retreating architectural masses" (Hartt 1970, 229).

"His whole body [is] bulging with *muscles*": this, said for Noah (Tolnay 1955, 25) is true for many among Michelangelo's figures, even for those of women—Cumaea is "incredibly muscular" (Hartt 1974, 449)—and particularly for backs: in Hartt no. 229 there is "the swell of the muscles across the astonishing back."

With old age "the forces which formerly swelled . . . [the figures] diminish and even vanish" (Tolnay 1960, 79).

It is particularly then that Michelangelo fights the concave more modestly by the mere rectangular (see chapter 6). Commenting on a female nude drawn by Michelangelo one may observe that "the feminine curve of the hip is almost blacked out; this looks like a correction in the sense of the anatomy of the male" (Weinberger 1967, 66). In The Last Judgment "the style of . . . [the] nudes is . . . thick-waisted: . . . [in] figures such as Christ, Peter, and Adam . . . waists equal or exceed their other dimensions, a development that begins with the Florentine Tomb statues" (Hibbard 1978, 163). In the late Michelangelo "men and women have the same thick waists" (Hartt 1964, 55). Michelangelo then had a "compulsion which made him thicken a torso till it is almost square . . ." (Clark 1956, 63): surely then not feminine, but no more flagrantly masculine either.

*Nudo* for Michelangelo connotes lack; *probably, obscurely being a woman.*

"Naked and alone . . ." (Girardi no. 67, stanza 12, l. 1): *survival endangered by separation (chapter 3).*

112

"Poor and naked . . ." (ibid.): *the Michelangelo from whom others withhold, whom they rob (chapter 3).*

"Defective *(zoppo)* and naked . . ." (Girardi no. 175, l. 8): *the Michelangelo who is incapable (chapter 5).*

"Against me, defective and naked, setting wings to your bow . . ." (ibid.). "Nude, I remain prisoner . . ." (Gilbert no. 96, ll. 13–14): the Michelangelo who is assaulted and subdued (chapter 7).

Nude, *rather than being sexually desired, I shall be ridiculous.* In a reported conversation where Michelangelo uses the metaphor of being deprived of his clothing, he imagines that "I would remain naked and give everybody matter for laughing" (Giannotti, 43).

But in Michelangelo's art to be nude is not miserable, it is glorious; not feminine, masculine. *Only in nudity are all of the members which the male body possesses visible.*

*Probably Michelangelo was so relentlessly inclined—before the 1530s—toward ideal male nudity in art so as to counteract a sense of having an insufficiently masculine body, small and ugly in its being, defective in its actions;* a body then replaced by the nudes imagined by Michelangelo: capable and beautiful, hence manifestations of God.

That ideal male of art was *probably also intended to counteract Michelangelo's horror not of being too little of a male, but of being a male at all;* the "giant" who "between the thick hairs of his legs . . . carries all kinds of monstrous . . . shapes" (Gilbert no. 66, ll. 19–20). Presenting again and again well-formed male genitals, Michelangelo *probably compensates for depreciating his own.*

Michelangelo seems torn between presenting bodies or their architectural equivalents as defying the law of gravity in an upward surge and succumbing to that law, sagging or prostrate (chapter 7). On the back of a sheet with the prone Tityos the same figure rises as the resurrected Christ. There is an "effortless conquest of gravity in the two Victory groups, and . . . a 'sagging' of all forms in the four *prigioni*" (Wilde 1978, 109). The late Christs

either "stand" distinctively "erect" on the Cross (Hartt nos. 410, 411, 416) or sag (in the Pietàs).

*Probably, as Michelangelo reduces his aspiration to high masculinity in old age, the sagging comes to prevail over the surging." "The evolution of St. Peter's Dome from an elevated curve inspired by Florence Cathedral to the classical hemisphere in Michelangelo's last solution prepared the way for the low, Pantheon-like dome of San Giovanni" (Ackerman 1961, 133). For "at San Giovanni . . . for the first time he affirmed the crushing weight of masonry construction. The aspiration of the ribs and lantern of St. Peter's Dome is . . . absent from the smooth semisphere of San Giovanni. . . . [Also there is a] gradual increase in plasticity from dome to base on both the interior and exterior which . . . stresses the accumulation of weight and forces towards the ground. . . . Nothing in Michelangelo's previous architecture prepares for what might be called the resignation of this late project. It is . . . an architectural version of the Pietàs and Passion drawings of the 1550s where again the forms sink . . . earthwards" (op. cit., 108–109). Already in the stairway of The Laurentian Library "[the visitor] seeks to mount . . . but the steps appear to be pouring downward . . ." (op. cit., 43), as the body of Christ in The Pietà in Florence.

# A FEW DATES

| | | | |
|---|---|---|---|
| 1475 | Michelangelo born<br>Put to nurse in Settignano | | |
| 1481 | Death of Michelangelo's mother | | |
| 1485 | Enters grammar school | | |
| 1488 | Apprentice to Ghirlandaio | | |
| 1489 | Enters the sculpture school of Bertoldo | | |
| 1490 | Enter the Medici household | 1490–1494 | The Madonna of the Stairs<br>The Battle of the Centaurs and Lapiths<br>The wooden Crucifix for S. Spirito |
| 1494–1495 | Bologna | 1494–1495 | an Angel |
| 1495–1496 | Florence | | |
| 1496–1501 | Rome | | the late nineties: Bacchus<br>The Pietà in Rome |
| 1501–1505 | Florence | | the first half of the 1500s:<br>David<br>The Doni Tondo<br>The cartoon of the Battle of Cascina<br>The Bruges Madonna<br>The Pitti Tondo<br>The Taddei Tondo |

115

| | | | |
|---|---|---|---|
| 1505–1506 | Rome | 1505–1545 | intermittently work on the tomb of Julius II |
| 1506 | Florence | | |
| 1506–1508 | Bologna | | |
| 1508–1516 | Rome | 1508–1512 | The Ceiling of the Sistine Chapel |
| 1513 | Death of Julius II | 1513–1516 | Major work on the tomb of Julius II |
| 1516–1534 | Florence | 1516–1520 | Work on the façade of S. Lorenzo |
| | | 1521–1534 | The Medici Chapel The Laurentian Library |
| 1528–1529 | Various kinds of involvement in the defense and siege of Florence | 1529 | Leda and the Swan |
| 1532–1534 | First phase of relation with Tommaso Cavalieri | mid-thirties: | Ganymede Tityos Phaëthon The Archers The Children's Bacchanal |
| 1534–1564 | Rome | 1535–1541 | The Last Judgment |
| | | 1543–1545 | The Conversion of St. Paul |
| 1536–1547 | Relation with Vittoria Colonna | 1545–1549 | The Martyrdom of St. Peter |
| | | 1545–1562 | Work on St. Peter's |
| 1555 | Urbino dies | the fifties | Work on The Pietà in Florence |
| 1564 | Michelangelo dies | the sixties | Work on The Pietà in Milan |

116

# REFERENCES

MICHELANGELO (under "Studies" below)

Drawings are designated by their numbers in: Hartt 1970, Tolnay
    1975–1979.
Poems are designated by their numbers in: Gilbert 1963, Girardi
    1960.
Letters are designated by their numbers in: Ramsden 1963.

## CONTEMPORARIES

*Il carteggio di Michelangelo,* v. 1–3. Firenze, Sansoni, 1965–1973.
Condivi, A. *The Life of Michelangelo.* Baton Rouge, Louisiana State
    University Press, 1976.
Cellini, B. *The Life of Benvenuto Cellini Written by Himself.* New York,
    Heritage Press, 1937.
Ficino, M. *Commento sopra il Convito di Platone.* Milano, Celuc, 1973.
Giannotti, D. *Dialogi dei giorni che Dante consumò nel cercare l'inferno
    e il purgatorio.* Firenze, Sansoni, 1939.
Hollanda, Francisco de. *Four Dialogues on Painting.* Oxford, Ox-
    ford University Press, 1928.
Vasari, G. *La vita di Michelangelo.* Milano, Ricciardi, 1962.

## STUDIES

Ackerman, J. S. (1961). *The Architecture of Michelangelo.* New York,
    Viking.

## REFERENCES

Barocchi, P. (1962). *Commento della Vita di Michelangelo di Giorgio Vasari.* v. 2–4. Milano, Ricciardi.

Blanckenhage, P. H. von (1973). *Die Ignudi der Madonna Doni,* 205–214. In *Festschrift für Gerhard Kleiner.* Tübingen, Wasmuth.

Clark, K. (1956). *The Nude: A Study in Ideal Form.* New York, Pantheon.

di Maio, R. (1978). *Michelangelo e la controriforma.* Bari, Laterza.

Einem, H. von (1973). *Michelangelo.* London, Methuen.

Frank. G. (1966). "The Enigma of Michelangelo's Pietà: A Study of Mother Loss in Childhood." *The American Imago* 23, 287–315.

Friedrich, H. (1964). *Epochen der italienischen Lyrik.* Frankfurt, Klostermann.

Garin, E. (1966). *Thinker.* In *Salmi,* v. 2, 1966, 517–530.

Gilbert, C. (1963). *Complete Poems and Selected Letters of Michelangelo,* Princeton, Princeton University Press.

Girardi, E. N., a cura di (1960). *Michelangelo Buonarroti, Rime.* Bari, Laterza.

Hartt, F. (1964). *Michelangelo.* New York, Abrams.

Hartt, F. (1968). *Michelangelo: The Complete Sculpture.* New York, Abrams.

Hartt, F. (1970). *Michelangelo Drawings.* New York, Abrams.

Hartt, F. (1974). *History of Italian Renaissance Art: Painting, Sculpture, Architecture.* New York, Prentice Hall.

Hartt, F. (1975a). *Michelangelo's Three Pietàs.* New York, Abrams.

Hartt, F. (1975b). *Thoughts on the Statue and the Niche,* 99–106. In *Art Studies for an Editor: 25 Essays for Milton S. Fox.* New York, Abrams.

Hartt, F. (1982). "The Evidence for the Scaffolding of the Sistine Ceiling." *Art History* 5, 273–286.

Hibbard, H. (1978). *Michelangelo: Painter, Sculptor, Architect.* New York, Vendôme.

Körte, W. (1955). "Das Problem des Nonfinito bei Michelangelo." *Römisches Jahrbuch für Kunstgeschichte* 7, 293–302.

Liebert, R. S. (1979). "Michelangelo's Early Work. A Psychoanalytic Study in Iconography." *The Psychoanalytic Study of the Child* 34, 463–525.

Liebert, R. S. (1983). *Michelangelo: A Psychoanalytic Study of His Life and Images.* New Haven, Yale University Press.

Lotz, W. (1974). *The Cinquecento, 147–326.* In L. Heydenreich and W. Lotz, *Architecture in Italy 1400–1600.* Harmondsworth, Penguin.

Mancusi-Ungaro, H. R., Jr. (1971). *Michelangelo: The Bruges Madonna and the Piccolomini Altar.* New Haven, Yale University Press.

Murray, L. (1980). *Michelangelo.* New York, Oxford University Press.

Orenland, J. D. (1980). "Mourning and Its Effect on Michelangelo's Art." *The Annual of Psychoanalysis* 8, 317–351.

Panofsky, E. (1939). *Studies in Iconology: Humanistic Themes in the Art of the Renaissance.* New York, Oxford University Press.

Papini, G. (1949). *Vita di Michelangelo nella vita del suo tempo.* Garzanti.

Peto, A. (1979). "The Rondanini Pietà: Michelangelo's Infantile Neurosis." *International Review of Psychoanalysis* 6, 183–199.

Pope-Hennessy, J. (1970). *Italian High Renaissance and Baroque Sculpture.* Oxford, Phaidon.

Ramsden, E. H. (1963). *The Letters of Michelangelo.* London, Owen.

Salmi, M., ed. (1966). *The Complete Work of Michelangelo.* London, Macdonald.

Salvini, R. (1978). *The Hidden Michelangelo.* Oxford, Phaidon.

Schulz, J. (1975). "Michelangelo's Unfinished Works." *Art Bulletin* 57, 366–373.

Steinberg, L. (1968). "Michelangelo's Florentine Pietà: The Missing Leg." *Art Bulletin* 50, 343–353.

Steinberg, L. (1970). *The Metaphors of Love and Birth in Michelangelo's Pietàs, 231–285.* In T. Bowie and C. V. Christenson, eds., *Studies in Erotic Art.* New York, Basic Books.

Steinberg, L. (1971). "Michelangelo's Madonna Medici and Related Works." *The Burlington Magazine* 113, 145–149.

Steinberg, L. (1975a). *Michelangelo's Last Paintings: The Conversion of St. Paul and the Crucifixion of St. Peter in the Cappella Paolina, Vatican Palace.* New York, Oxford University Press.

Steinberg, L. (1975b). "Michelangelo's "Last Judgment" as Merciful Heresy." *Art in America* 63, 6, 49–64.

Steinberg, L. (1980a). "The Line of Fate in Michelangelo's Painting." *Critical Inquiry* 6, 411–454.

Steinberg, L. (1980b). "A Corner of the Last Judgment." *Daedalus* 109, 207–273.

119

Steinmann, E. (1932). *Michelangelo e Luigi del Riccio*. Firenze, Vallecchi.

Sterba, R. and E. (1956). "The Anxieties of Michelangelo Buonarroti." *International Journal of Psychoanalysis* 37, 325–330.

Sterba, R. F. and Sterba, E. (1978). "The Personality of Michelangelo: Some Reflections." *The American Imago* 35, 158–177.

Stokes, A. (1955). *Michelangelo: A Study in the Nature of Art*. London, Tavistock.

Symonds, J. A. (1893). *The Life of Michelangelo Buonarroti*. London, Nimmo.

Testa, J. A. (1979). "The Iconography of *The Archers:* A Study of Self-concealment and Self-revelation in Michelangelo's Presentation Drawings." *Studies in Iconography* 5, 45–72.

Tolnay, C. de (1947). *The Youth of Michelangelo*. Princeton, Princeton University Press.

Tolnay, C. de (1948). *The Medici Chapel*. Princeton, Princeton University Press.

Tolnay, C. de (1954). *The Tomb of Julius II*. Princeton, Princeton University Press.

Tolnay, C. de (1955). *The Sistine Ceiling*. Princeton, Princeton University Press.

Tolnay, C. de (1960). *The Final Period: Last Judgment, Frescoes of the Pauline Chapel, Last Pietàs*. Princeton, Princeton University Press.

Tolnay, C. de (1968). *Le Madonne di Michelangelo: Nuove ricerche sui disegni*. Roma, Accademia dei Lincei.

Tolnay, C. de (1975). *Michelangelo: Sculptor Painter Architect*. Princeton, Princeton University Press.

Tolnay, C. de (1975–1979). *Corpus dei disegni di Michelangelo*. Novara, Istituto geografico de Agostini.

Weinberger, M. (1967). *Michelangelo the Sculptor*. New York, Columbia University Press.

Wilde, J. (1978). *Michelangelo: Six Lectures*. Oxford, Oxford University Press.

Wind, E. (1968). *Pagan Mysteries in the Renaissance*. New York, Norton.

# ILLUSTRATIONS

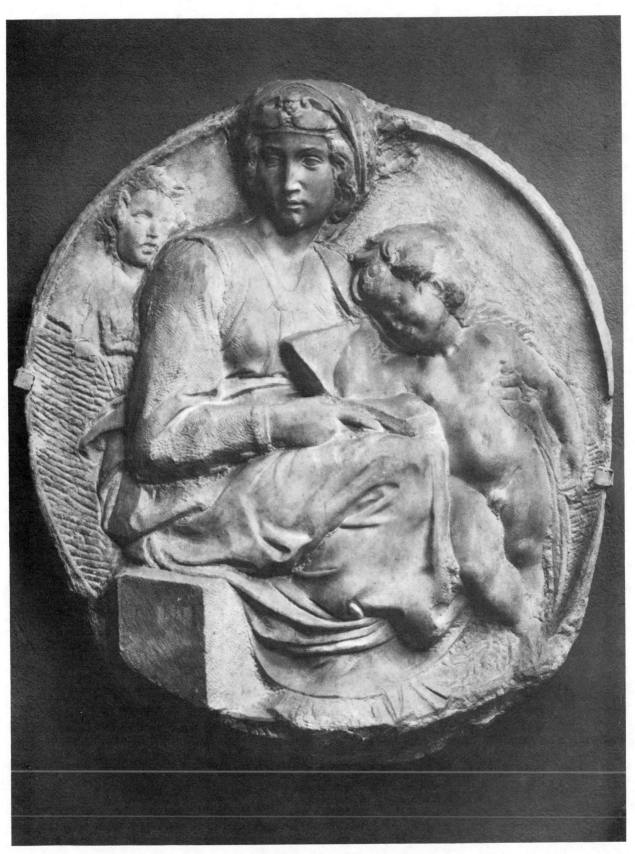

**1.** The Pitti Tondo. ALINARI/ART RESOURCE, N.Y.

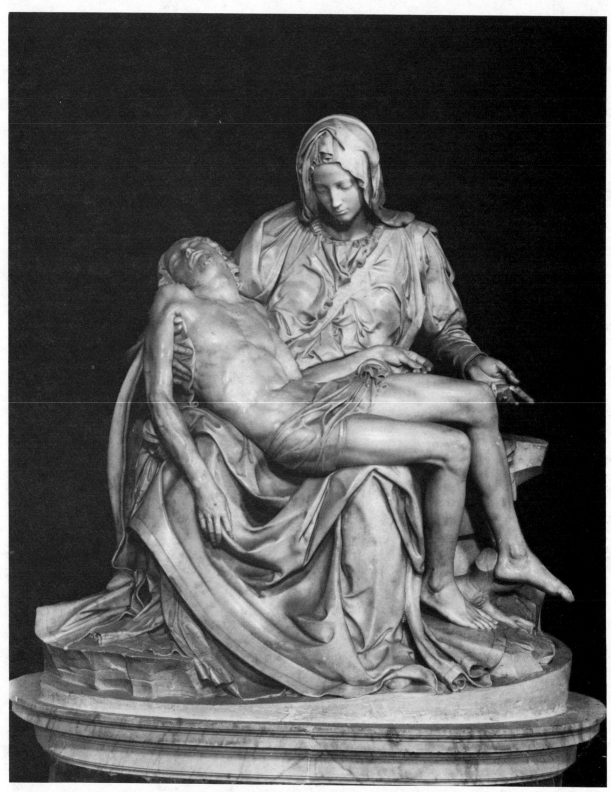

**2.** The Pietà in Rome. ALINARI/ART RESOURCE, N.Y.

**3.** The Bruges Madonna. ALINARI/ART RESOURCE, N.Y.

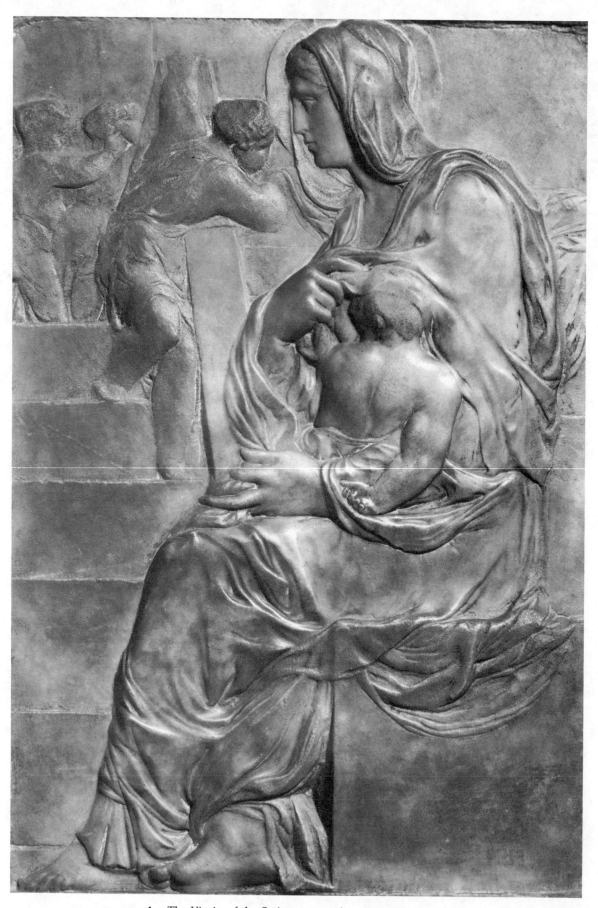

**4.** The Virgin of the Stairs. ALINARI/ART RESOURCE, N.Y.

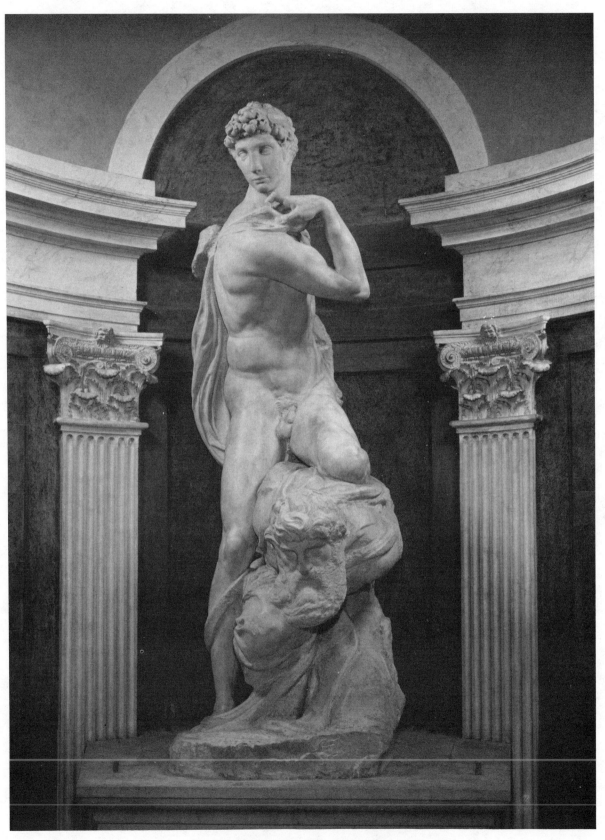

**5.** The Victory. SCALA/ART RESOURCE, N.Y.

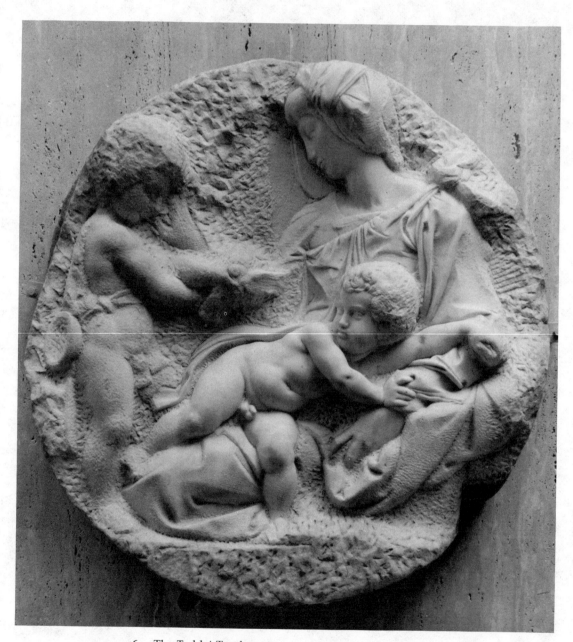

**6.** The Taddei Tondo. ROYAL ACADEMY OF ARTS, LONDON.

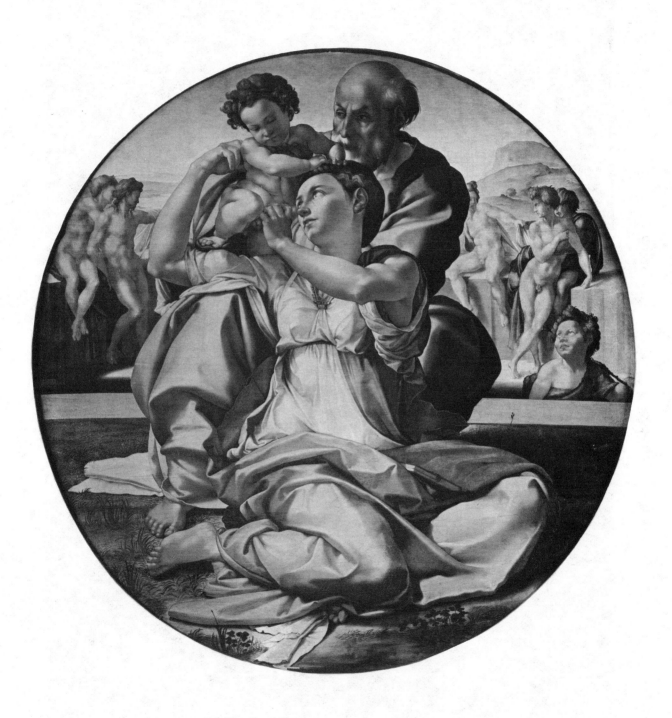

**7.** The Doni Tondo. ALINARI/ART RESOURCE, N.Y.

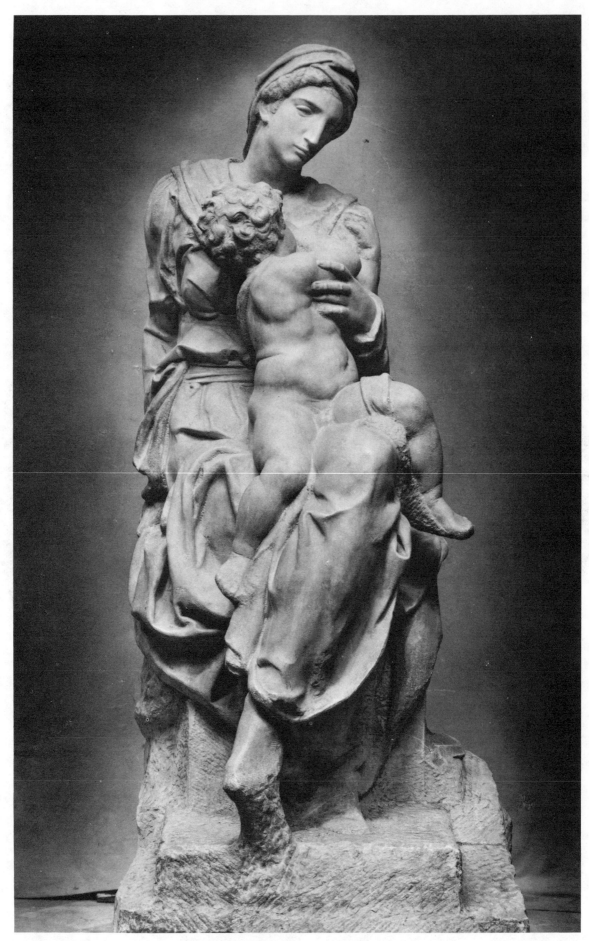

**8.** The Medici Madonna. ALINARI/ART RESOURCE, N.Y.

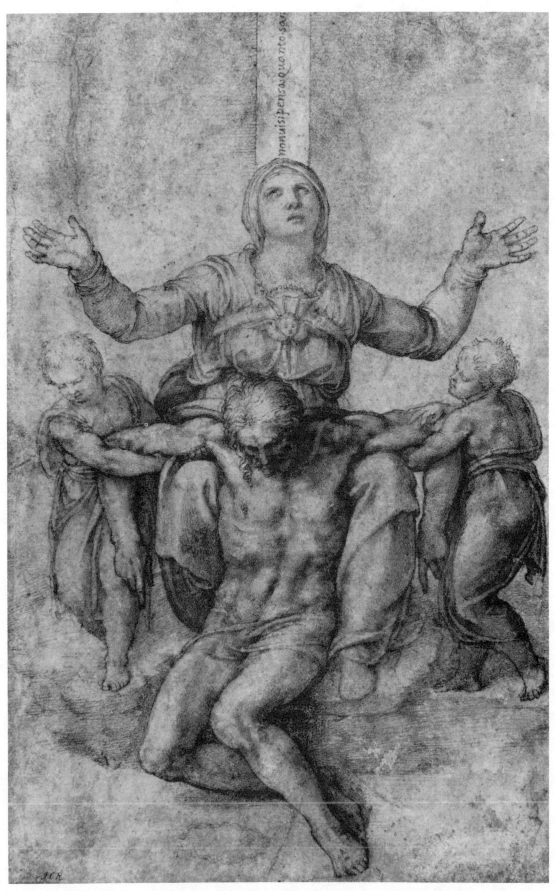

**9.** The Pietà for Vittoria Colonna. THE ISABELLA STEWART GARDNER MUSEUM,
BOSTON/ART RESOURCE, N.Y.

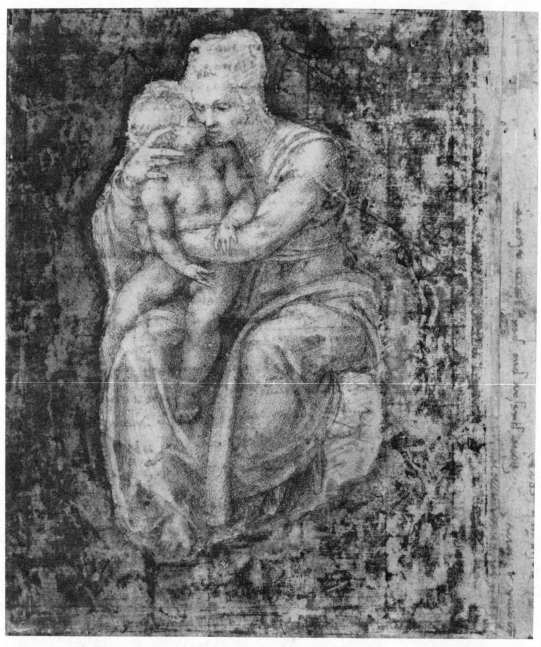

**10.** Madonna and Child, drawing number 12772 recto, ROYAL LIBRARY, WINDSOR
CASTLE. REPRODUCED BY GRACIOUS PERMISSION OF HER MAJESTY QUEEN ELIZABETH II.

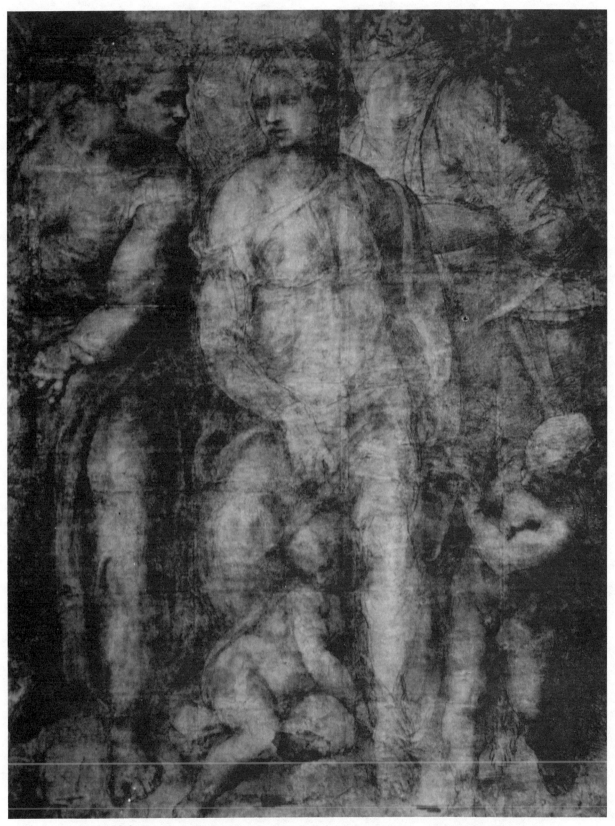

**11.** Holy Family with Saints, London, British Museum, W. 75. THE BRIDGEMAN ART
LIBRARY/ART RESOURCE, N.Y.

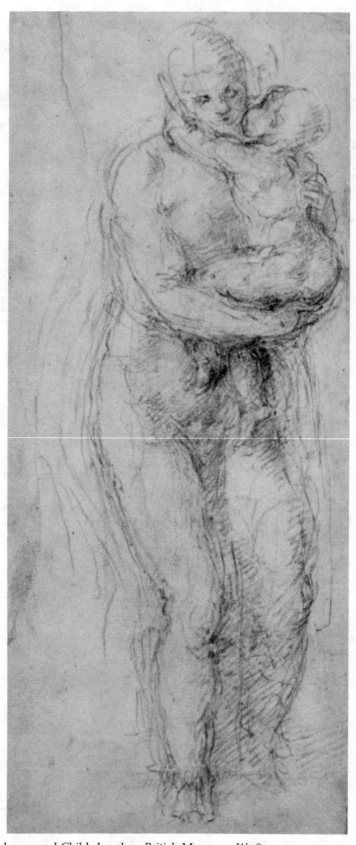

**12.** Madonna and Child, London, British Museum, W. 83. THE BRIDGEMAN ART LI-
BRARY/ART RESOURCE, N.Y.

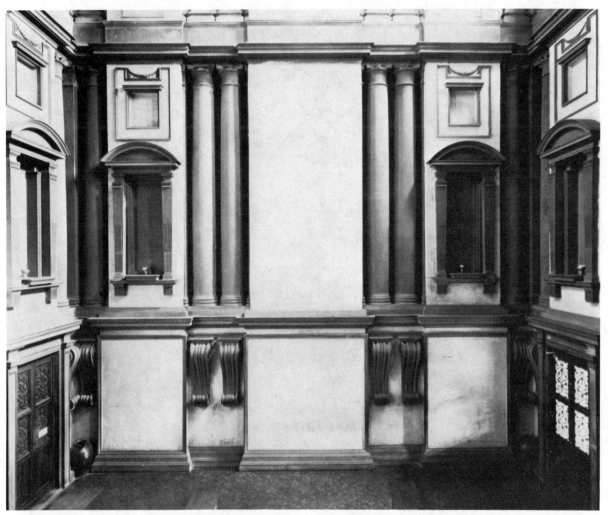

**13.** The Laurentian Library. SCALA/ART RESOURCE, N.Y.

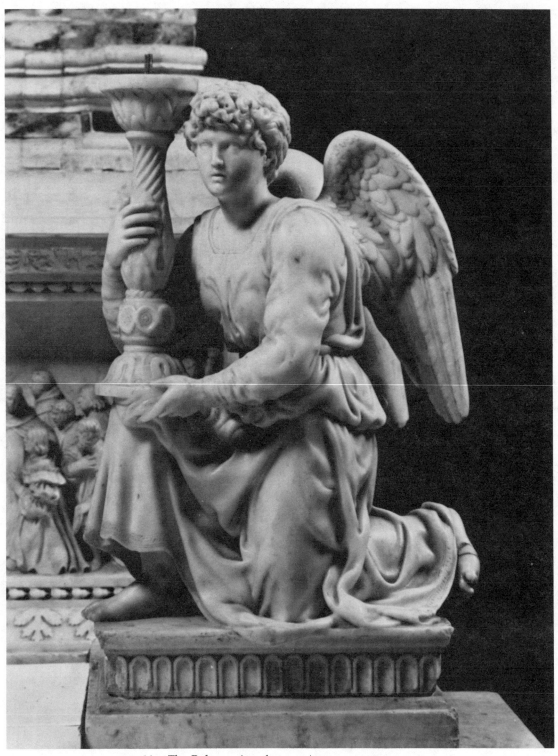

**14.** The Bologna Angel. SCALA/ART RESOURCE, N.Y.

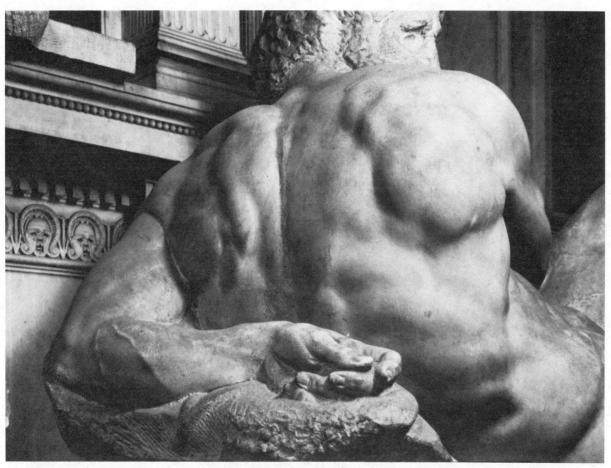

**15.** Giorno. SCALA/ART RESOURCE, N.Y.

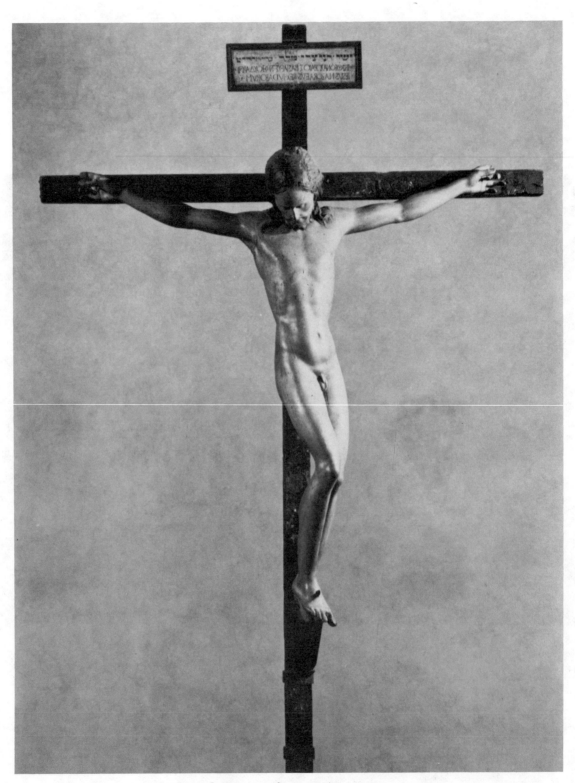

**16.** Santo Spirito, crucifix. SCALA/ART RESOURCE, N.Y.

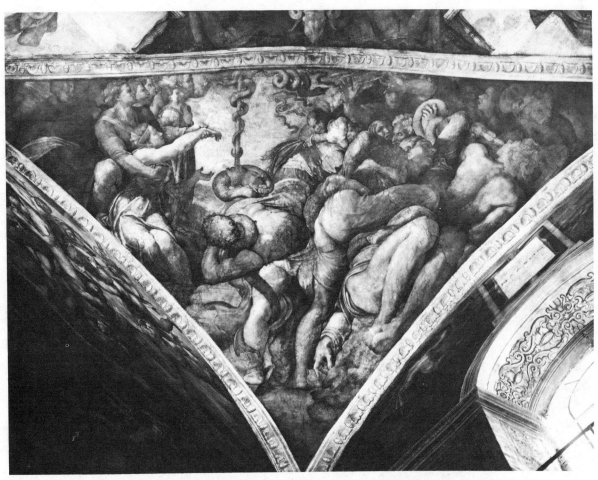

**17.** The Brazen Serpent and The Fiery Serpents. ALINARI/ART RESOURCE, N.Y.

**18.** The Medici Chapel, door area. ALINARI/ART RESOURCE, N.Y.

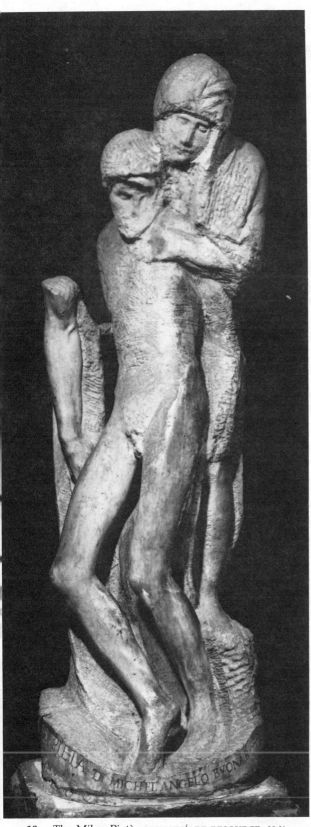

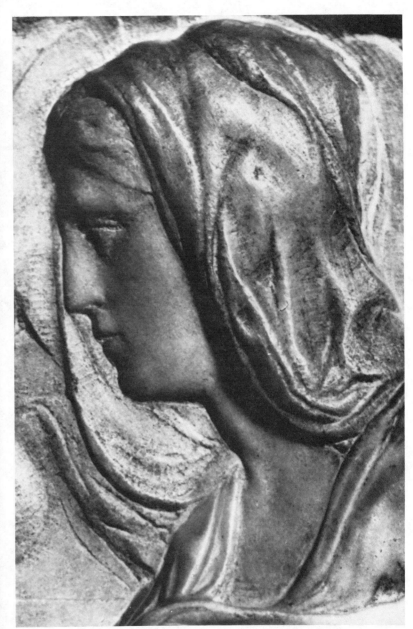

20.   The Virgin of the Stairs. ALINARI/ART RESOURCE, N.Y.

19.   The Milan Pietà. ALINARI/ART RESOURCE, N.Y.

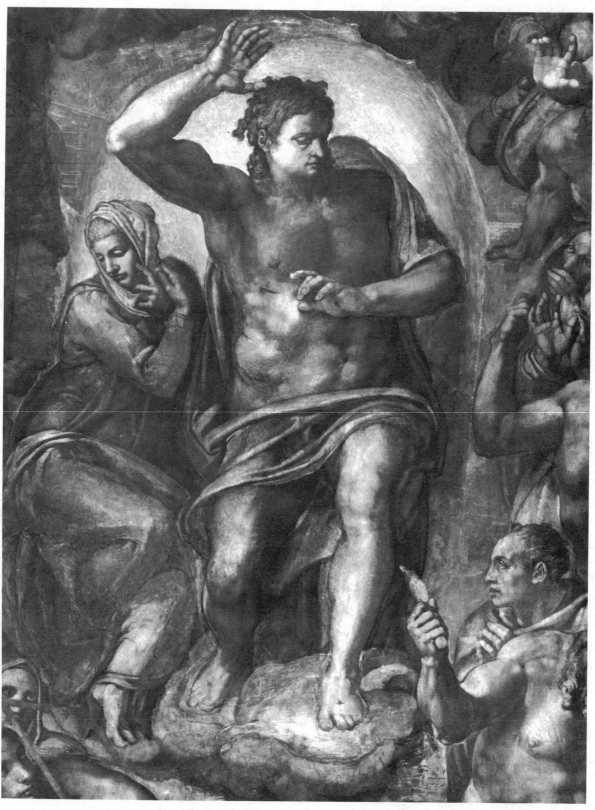

**21.** The Last Judgment. ALINARI/ART RESOURCE, N.Y.

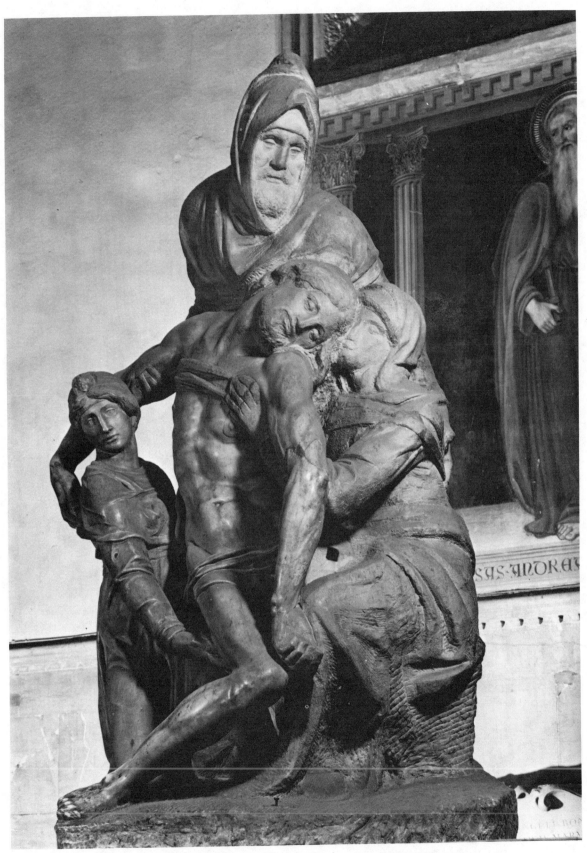

**22.** The Florence Pietà. SCALA/ART RESOURCE, N.Y.

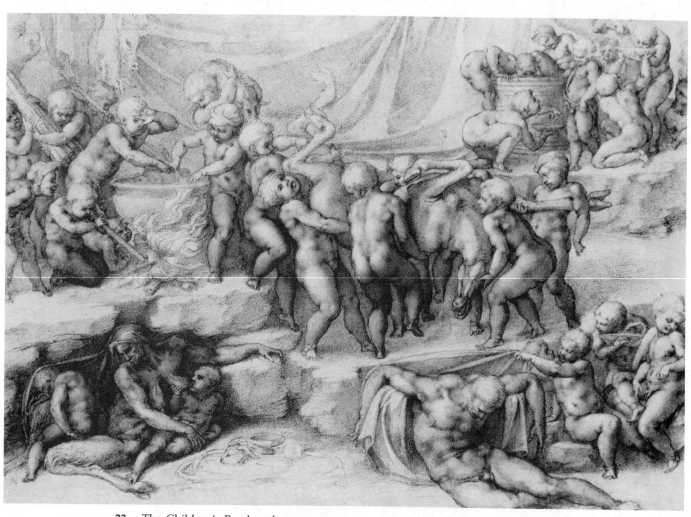

**23.** The Children's Bacchanal, ROYAL LIBRARY, WINDSOR CASTLE. COPYRIGHT RESERVED.
REPRODUCED BY GRACIOUS PERMISSION OF HER MAJESTY QUEEN ELIZABETH II.

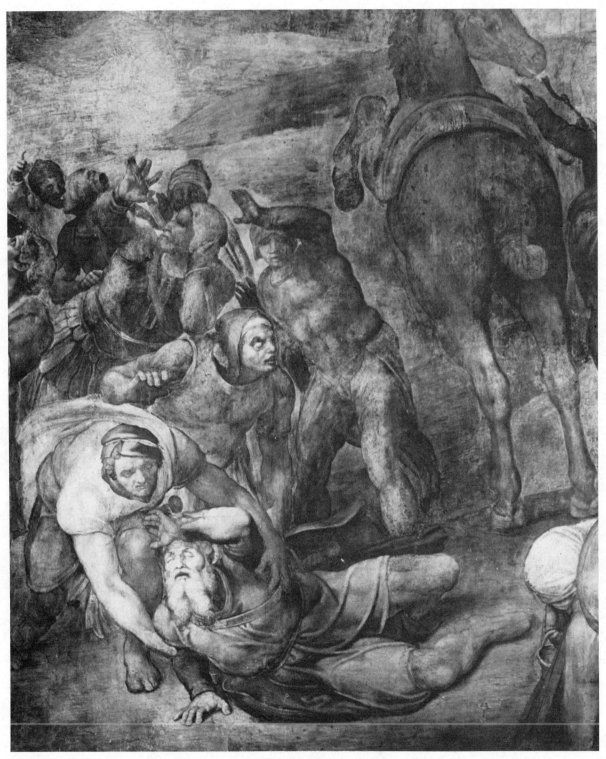

**24.** The Conversion of St. Paul. SCALA/ART RESOURCE, N.Y.

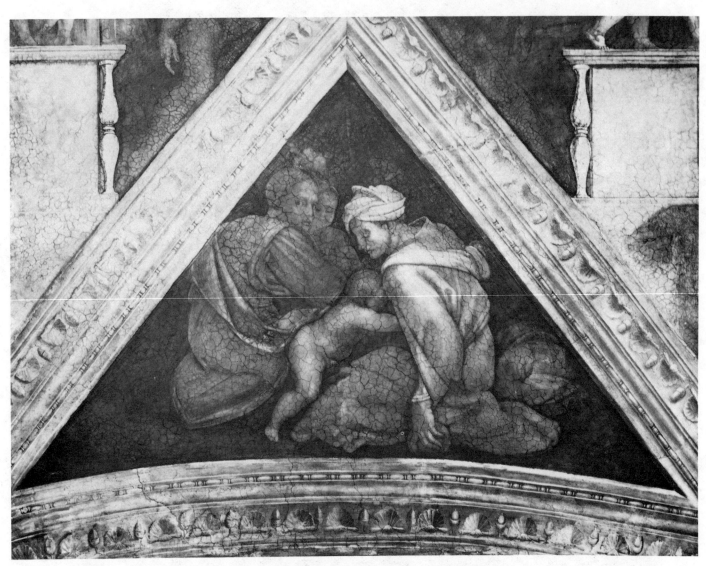

**25.** Ozias and His Mother. ALINARI/ART RESOURCE, N.Y.

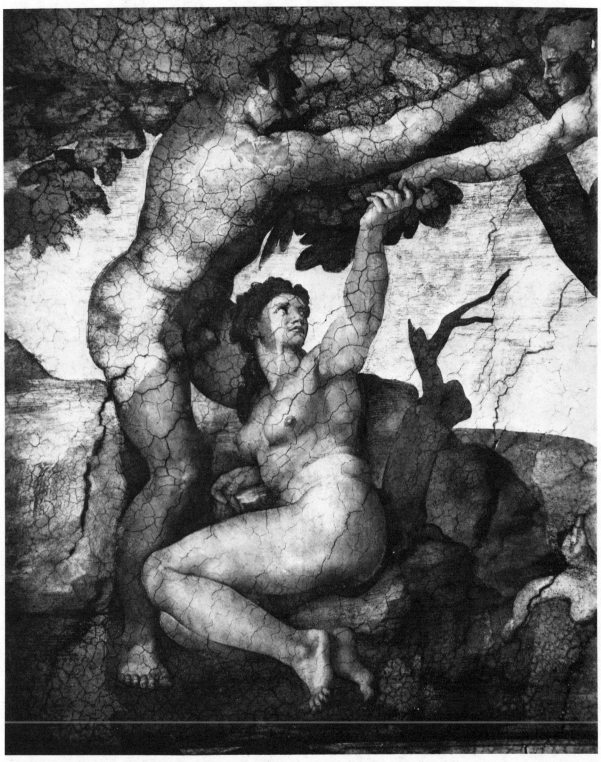

**26.** The Fall, Adam. ALINARI/ART RESOURCE, N.Y.

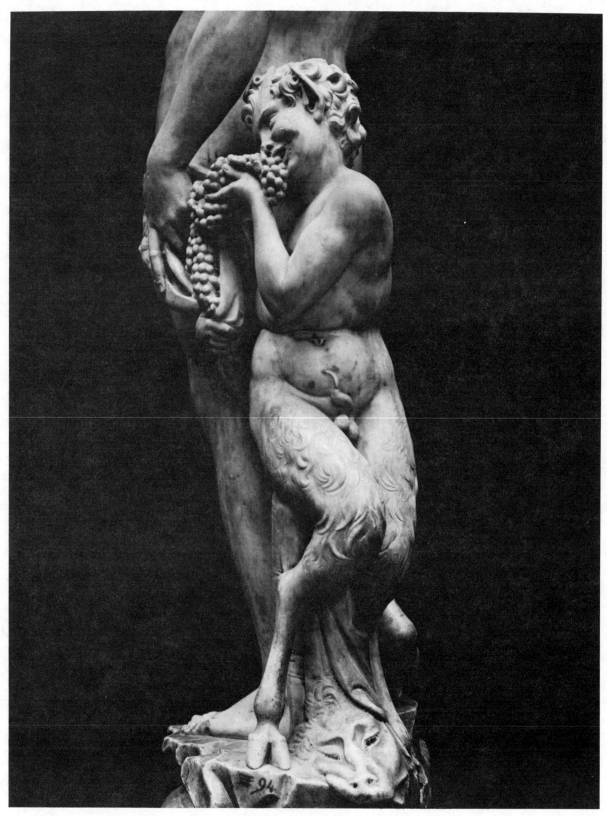

**27.** Bacchus, the satyr. ALINARI/ART RESOURCE, N.Y.

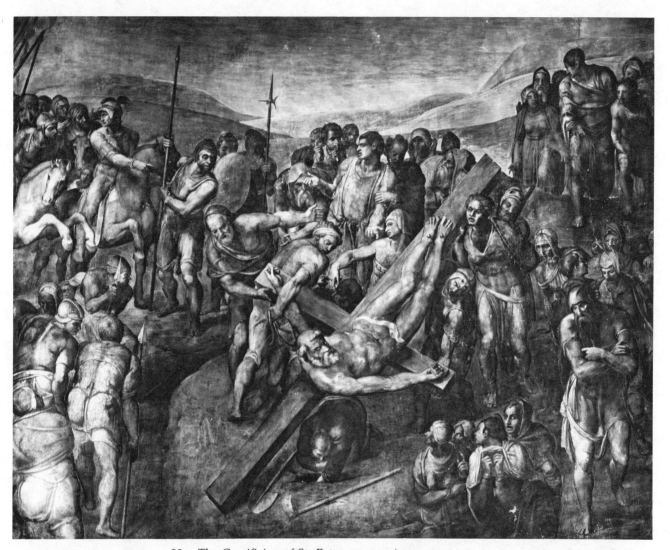

**28.** The Crucifixion of St. Peter. ALINARI/ART RESOURCE, N.Y.

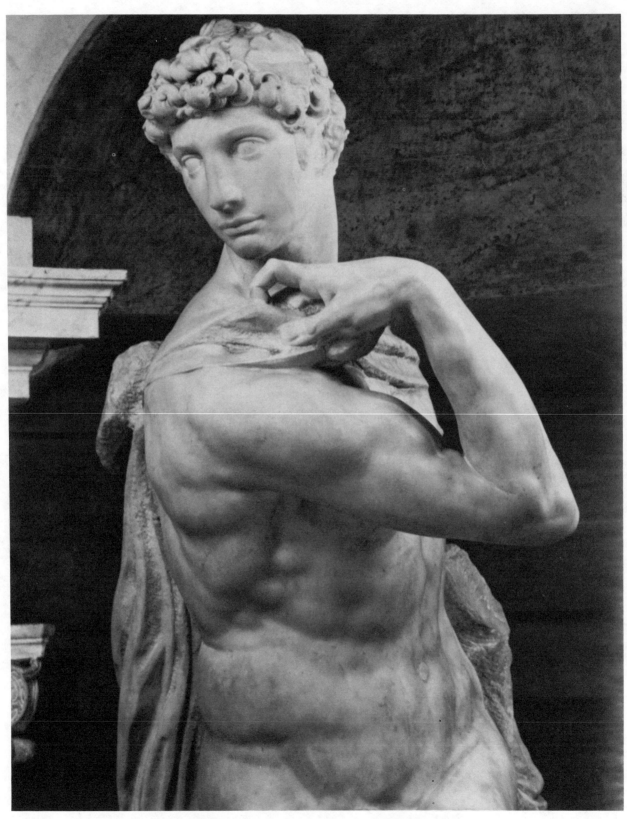

**29.** The Victory, the head. SCALA/ART RESOURCE, N.Y.

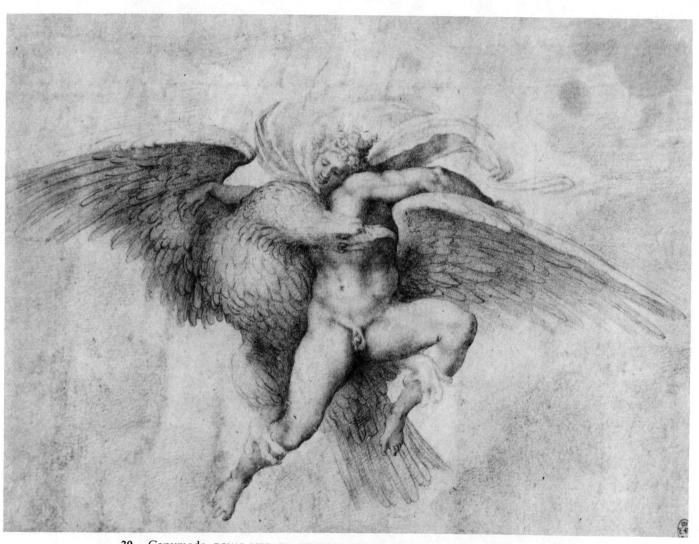

**30.** Ganymede.

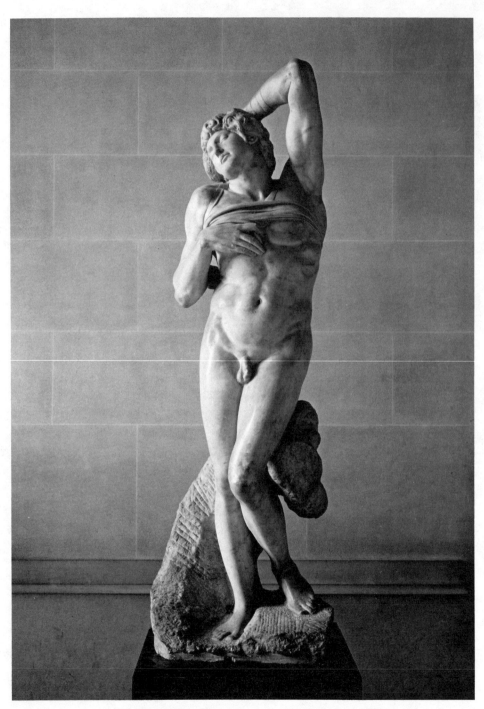

**31.** The Dying Slave. SCALA/ART RESOURCE, N.Y.

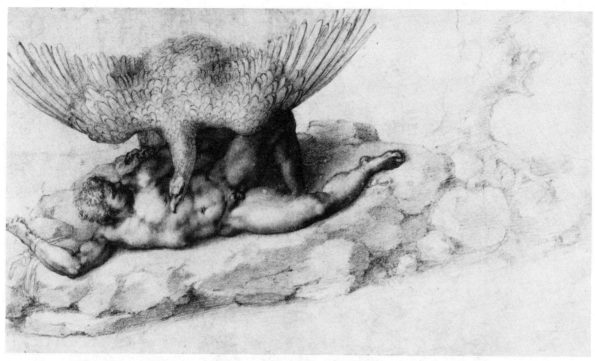

**32.** Tityos. ROYAL LIBRARY, WINDSOR CASTLE. COPYRIGHT RESERVED. REPRODUCED BY
GRACIOUS PERMISSION OF HER MAJESTY QUEEN ELIZABETH II.

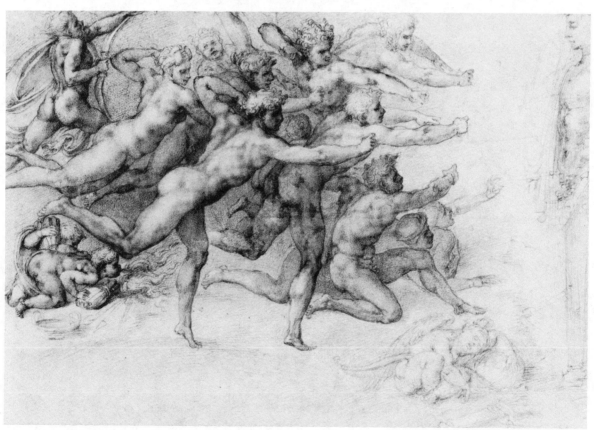

**33.** The Archers. ROYAL LIBRARY, WINDSOR CASTLE. COPYRIGHT RESERVED. REPRODUCED
BY GRACIOUS PERMISSION OF HER MAJESTY QUEEN ELIZABETH II.

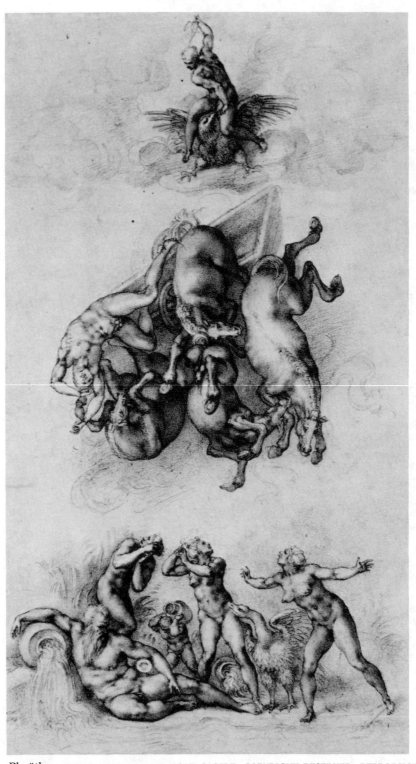

**34.** Phaëthon.

# INDEX